QUILTS
FROM THE
INDIANA AMISH

QUILTS
FROM THE
INDIANA AMISH
A Regional Collection

DAVID POTTINGER

Photographs by Susan Einstein

E. P. DUTTON, INC. NEW YORK
In association with the
MUSEUM OF AMERICAN FOLK ART NEW YORK

First published, 1983, in the United States by E.P. Dutton, Inc., New York./ All rights reserved under International and Pan-American Copyright Conventions./ No part of this book may be reproduced or transmitted in any form or by any means, electronic or mechanical, including photocopy, recording, or any storage and retrieval system now known or to be invented, without permission in writing from the publishers, except by a reviewer who wishes to quote brief passages in connection with a review written for inclusion in a magazine, newspaper, or broadcast. / Published simultaneously in Canada by Clarke, Irwin & Company Limited, Toronto and Vancouver. / Printed and bound by Dai Nippon Printing Co., Ltd., Tokyo, Japan. Library of Congress Catalog Card Number: 83-70929. / ISBN 0-525-48043-9 (DP); ISBN 0-525-93285-2 (Cloth). 10 9 8 7 6 5 4 3 2 1 First Edition

CONTENTS

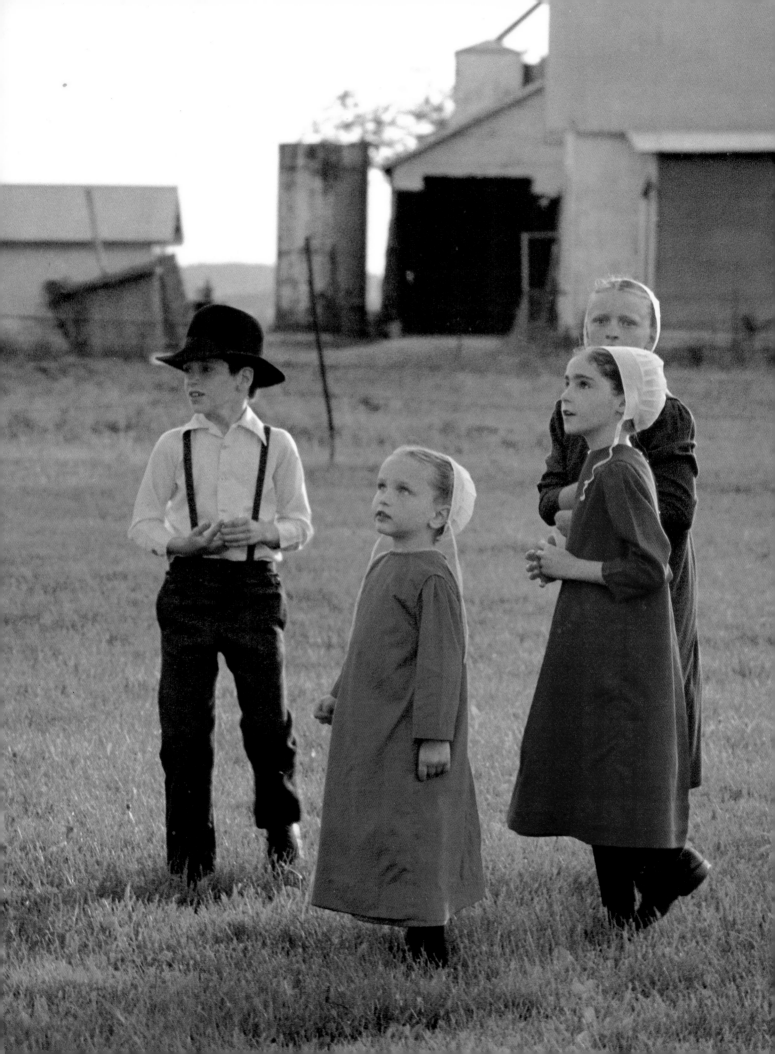

PREFACE

The Amish people have been a topic of interest for many years. A good many books have told us about their background and special way of life and illustrated some of their finest quilts. Here, for the first time, is presented a regional collection of Amish quilts gathered from a two-county area in northern Indiana and dating from about 1875 through 1940.

Here also is my personal story, for in the process of assembling this quilt collection I became both a resident and a storekeeper in the Old Order Amish community at Honeyville, Indiana.

To Amos D. Bontrager and his late wife, Bertha, my sincere gratitude, for without their interest and cooperation the collection and the book would not have been possible. To my friends and neighbors in and around Honeyville my deepest thanks for the friendship and support that have been a continuing source of inspiration. To my daughter, Charity, my gratitude for her hours spent going from farm to farm in search of additional quilts. A special thanks to Susan Einstein for her patience, sensitivity, and expertise that resulted in the photographs of the Amish people, the Amish country, and the Amish quilts published in this book. Thanks also to Rod Kiracofe and Michael Kile for their careful cataloguing of the entire collection. Both Robert Bishop, director of the

Museum of American Folk Art in New York City, and Cyril Nelson, editor at E.P. Dutton, deserve special acknowledgment for their confidence in me and for their professional direction.

Most of all, I am grateful to be able to share this once-in-a-lifetime opportunity.

My thanks to the following for permission to reproduce quilts that are now in their collections: America Hurrah Antiques, New York City; Marna Anderson, New York City; Bank of America Corporation Art Collection, San Francisco, California; Daniel Einstein and Marsha Goodman, Los Angeles, California; The Esprit Collection, San Francisco, California; Janis Ito, Berkeley, California; Nanny Montgomery; Museum of American Folk Art, New York City; Charity Pottinger, Highland Beach, Florida; Victor Pottinger, Palm Beach, Florida; Private collection, Los Angeles, California; Security Pacific National Bank, Los Angeles, California; Clyde and Darlene Shumway, Annandale, Virginia; Julie Siegmund, New York City; Skidmore, Owings and Merrill, San Francisco, California; Levi Strauss & Company Art Collection, San Francisco, California; Kate Taylor, Ross, California; Marjorie van Dusen and Patricia Schuman; Pamela van Vurst, Birmingham, Michigan.

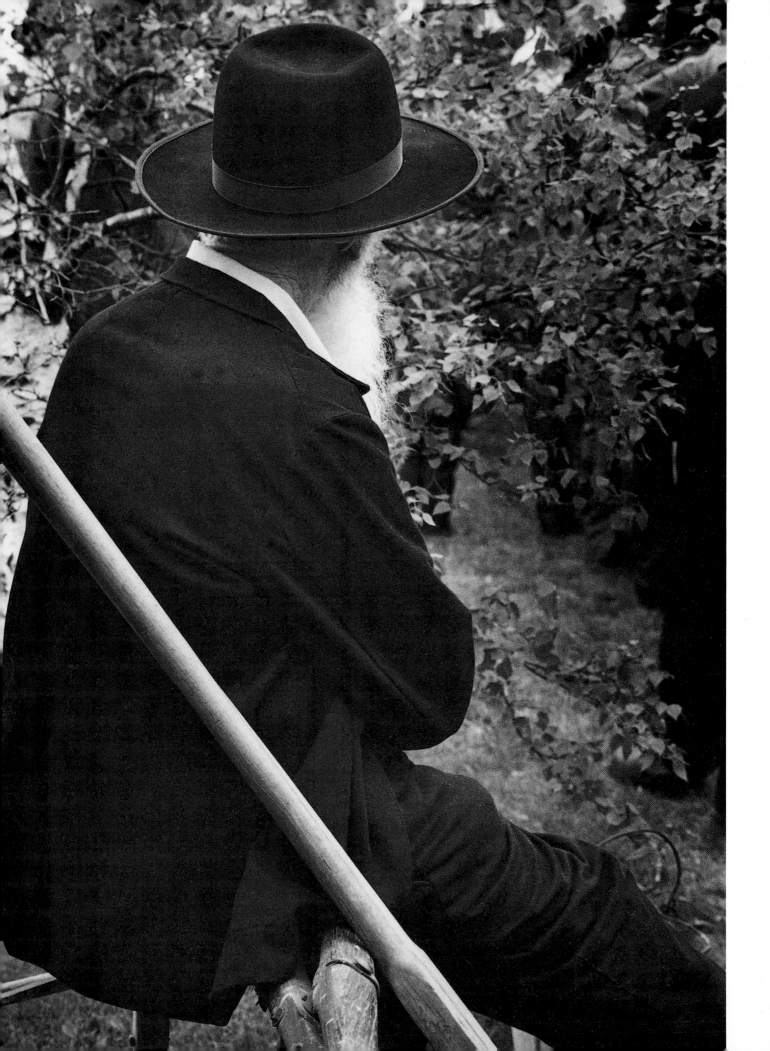

INTRODUCTION

Bertha, Amos, and I, together with a list of people who had old quilts for sale, were on our way to the home of Mrs. Joe Miller, near Lagrange, Indiana, for our first stop of the day. She greeted us warmly, and as we entered through the kitchen her daughters were busy canning fresh applesauce, which filled the house with the sweet, spicy smell of cinnamon. While we stood in the center of the large living room, with its brightly polished wood floor, Mrs. Miller opened the cedar chest standing in the corner and then placed three neatly folded quilts on a table. As we looked at each quilt, Mrs. Miller was able to tell us who had made the quilt and where and when it was made. She was also frank about the price she wanted for each, and after the sale was cleared with her daughters, we completed the transaction.

Just before leaving, I asked if she had any other old quilts she had not shown us. At first she said no, but then she remembered that in the bedroom there was a piece under her sleeping grandson that might be of interest to us. Some years ago she had made a new quilt and used an old, worn quilt for the batting (the inner layer), but she could not remember the old quilt's pattern. So, as Bertha gently lifted the child a few inches off the bed, I quickly slipped the quilt free. The excitement of gambling on the unknown sent us straight home, where we carefully snipped open the new outer covering and exposed a well-worn but early Sunshine and Shadow quilt.

This was a typical day, of which there were many, spent with my Amish friends Amos and Bertha Bontrager. Assembling the quilt collection was certainly exciting and fun, but the experience of becoming friends with the Amish was more deeply rewarding and satisfying than acquiring the quilts themselves. Each day I was getting to know more of the families in the community, and although I had no way of knowing it then, I was about to experience a major change in my life.

For years I had been deeply involved in two main areas of interest and occupation: one as the owner of a plastics manufacturing firm, and the second as a dealer in and collector of American antiques. Although the two businesses may seem worlds apart, it was this combination of activities that eventually brought me to the Old Order Amish community in Honeyville, Indiana, which offered me the opportunity to assemble the regional collection of Amish quilts illustrated in this book.

Since the early 1970s I had been traveling throughout the area surrounding Elkhart, Indiana, as this was the production center for recreational

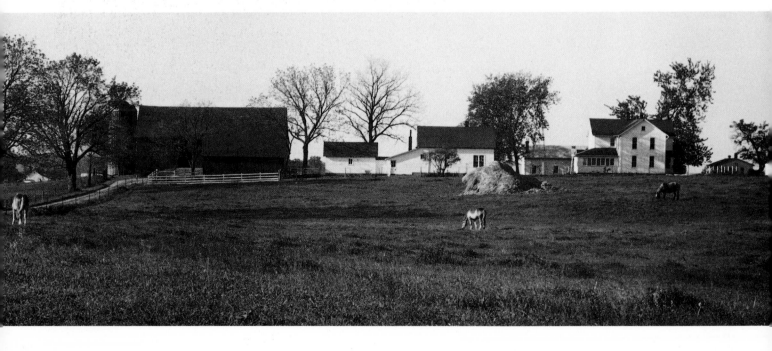

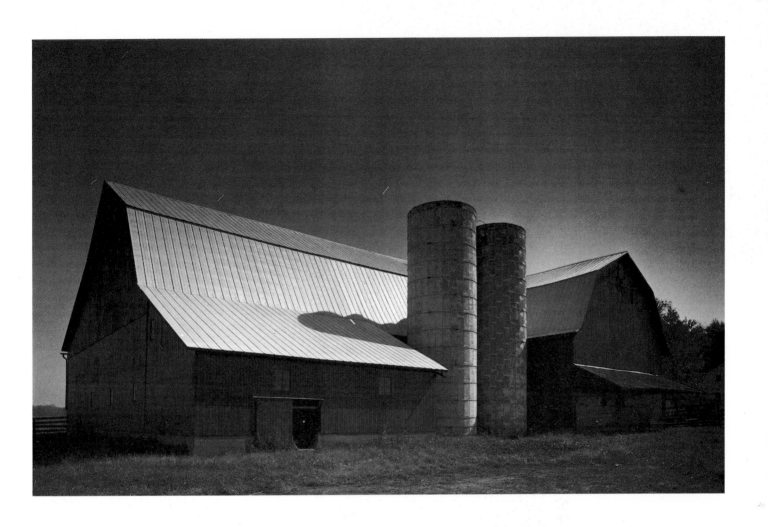

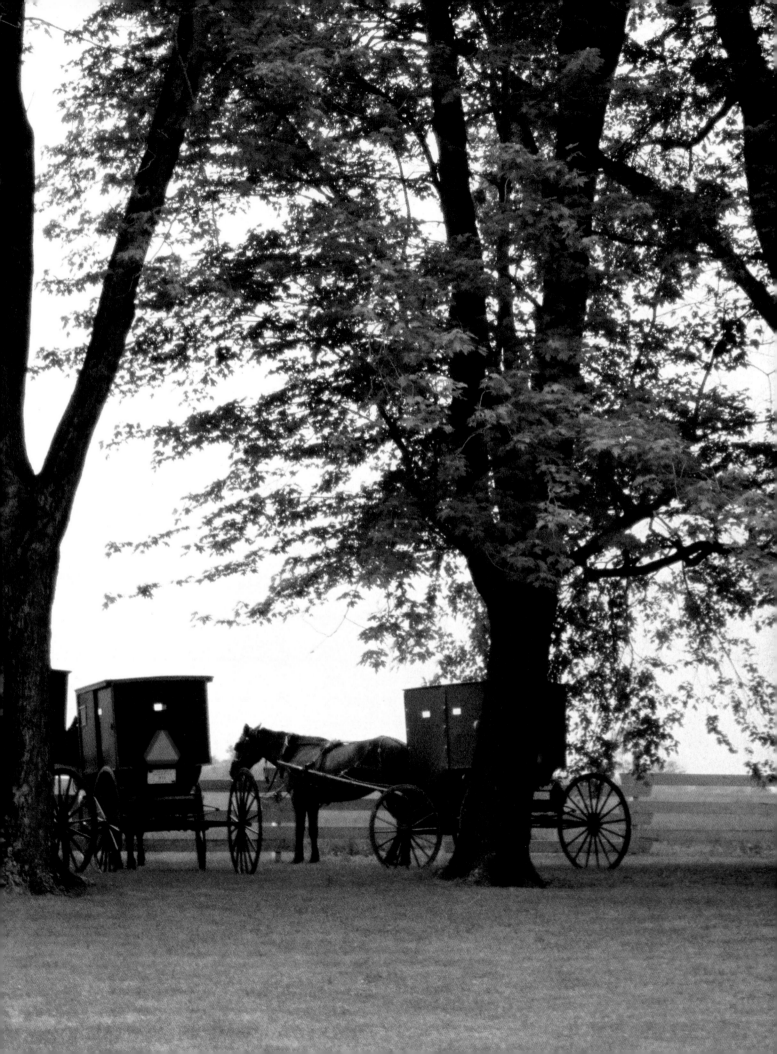

vehicles, and the lightweight plastics I manufactured found many applications in the industry.

Elkhart County and neighboring Lagrange County are the home for some 10,000 Amish men, women, and children, whose ancestors first settled there in 1841. The area has since become the third largest Amish community in this country, and it now covers approximately 150 square miles. Having been raised in a rural town just outside of Detroit, I felt at home in this gently rolling countryside, dotted with its large well-kept farms, and I spent many evenings driving throughout the area, just soaking up the sights. It was a welcome relief from the business pressures of the day, and although I was relaxed and enjoying it thoroughly, I was somewhat shy about making contact with these very reserved people, until my search for Amish quilts finally helped me to bridge that gap.

For several years I had been buying and selling Amish quilts brought into my antiques shop from eastern communities surrounding Lancaster, Pennsylvania. Although these are somewhat limited in their variety of design, the seemingly inexhaustible combinations of unusual colors, along with their excellent quilting, not only made them collectible as bedcovers but also gave them a much wider appeal as large, decorative wall pieces.

Until the late 1970s, most of the collected, published, and exhibited material had focused on the quilts from the Lancaster, Pennsylvania, region, with less attention given to the midwestern examples. However, I realized that if there were that many quilts to be found in the East, there must be many examples in midwestern Amish communities as well. I was not aware of any serious effort to collect quilts from this area; in fact, it seemed as if dealers and collectors sought only the rarest examples of midwestern Amish quilts. Although my initial interest was to acquire quilts for resale through my antiques shop, my instinct was not to sell until I learned more about the area and just what was available there. As the months went by, it became apparent that there was, indeed, a large quantity of quilts still in the hands of Indiana's Amish families, so a fine regional collection could be assembled.

However, it appeared that there were only two ways of purchasing quilts from this community. One was to attend the local estate sales, and, if the children had not taken the old quilts as family heirlooms, they were then left to the highest bidder. The other way was to make direct contact with each family by going from farm to farm in search of quilts.

In June 1974, on the recommendation of a friend, I went to the home of Amos D. Bontrager and his wife, Bertha. (Bertha had heard that there was a man from Michigan looking for old quilts and had left word for me to contact her.) They were both busy working in their garden when I arrived. I remember having a very special feeling about that moment, and, as it turned out, my growing friendship with Amos and Bertha was a key factor in making it possible for me to build the collection, and finally, in prompting my move to their community.

The majority of Amish women still make quilts as part of their everyday life. Some are intended for home use, others are made for gifts or for donation to organizations, and still others are for sale. Bertha was involved in the sale of quilts, and although she did some piecing herself, most of her activity was in directing and distributing the quilts made by her neighbors.

After a short discussion in the garden, the Bontragers asked if I would stay for dinner so we could discuss my project further.

In the three years that followed I made several trips to the area each month on behalf of my plastics business, and I arranged my schedule so that I would have Friday evening and all day Saturday to spend with Amos and Bertha. On each visit there would be a list of people to see who had shown an interest in selling old quilts. So off the three of us would go, buying nearly everything that was offered. Those that were damaged beyond repair would be cut up to make pillow covers, while the balance began to fill a closet at home.

Most of the quilt visits followed a general pattern. Bertha made the introductions, and we would be invited into the living room. This activity always seemed to be of great interest to the children, who usually formed a semicircle at one end of the room. We began the visit by discussing local events, and then in a short while the housewife would excuse herself and disappear in search of quilts. Soon she would return with one or more neatly folded quilts and lay them on a table. Then one by one, each taking a corner, we carefully unfolded them. When we came to a particularly graphic design, I would ask to have it held up vertically so that I could view it from across the room. It was moments like this that made me conscious of how different we were in judging the same object. Here was a quilt that for the Amish of today was too small, too thin, and too dark to be of much use or beauty. And there I was, standing across

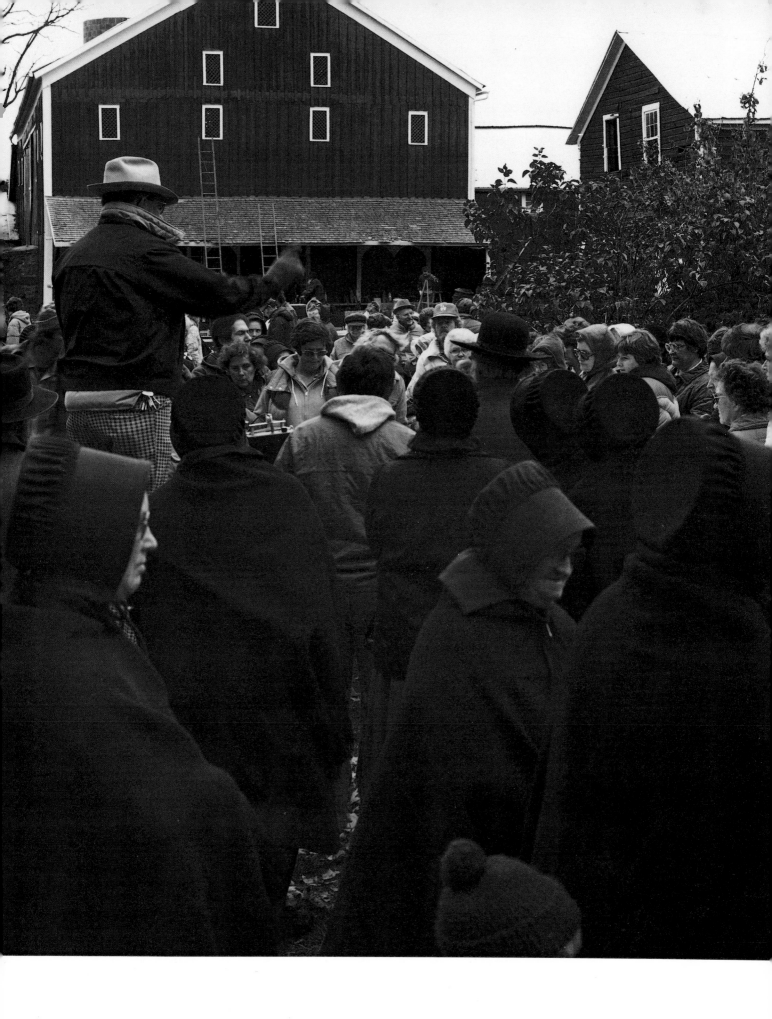

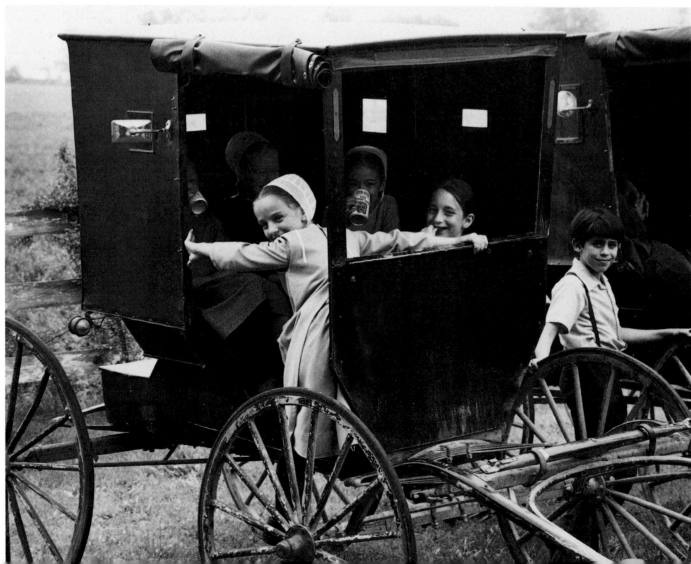

the room, squinting at this old bedcover and offering congratulations to the maker. It must have been confusing to her.

Then came the difficult part—settling on a price for the quilt. Early on I learned that the Amish will generally not show a quilt unless it is for sale. I was always pleased when the owner was definite about the price she wanted, but more often than not this matter was left up to Bertha and me on the grounds that we were more experienced and that the housewife would be pleased with whatever we suggested. I cannot remember a single situation where both parties were not satisfied with the transaction. Also, I purchased almost every quilt that was offered, which meant that the family received the maximum in cash, and which allowed me to assemble the large variety of patterns now in the collection. After we had agreed on a price, I would record any and all information about each quilt. Often they were dated and initialed in the quilting, which made the task easier. In many cases I was buying directly from the woman who had made the quilt or had helped her mother or a relative in piecing it. In those instances I would also inquire about the selection of patterns and the choice of colors, and almost without exception I discovered that the choice of design was based on their having templates available, either from a previous quilt or from a neighbor. This was also true when choosing the quilting design to be used. There is considerable lending and copying of the templates, but usually, once a woman had found three or four combinations that suited her, she would often repeat those designs.

Colors, too, were generally a result of what was available. Once cloth for the background had been purchased, scraps of old and new clothing would be used for the small pattern pieces.

Starting about 1940 changes began taking place in Amish quiltmaking, so that the quilts being produced today have little resemblance to those shown in this book. The relatively recent availability of synthetic blends of batting and fabric, although easier to sew through and certainly offering improved maintenance and wearability, caused many of the changes. Synthetic batting is thick (older quilts were generally lined with a thin cotton batting) and produces a quilt that is more practical in terms of warmth, but it has the disadvantage of restricting the number of quilting stitches possible per inch. Thus the quilting in newer quilts is less fine than that found in older examples. Moreover, many of the synthetic fabrics have a glossy surface that affects the depth of color.

The influence of the outside world on the Amish has also caused changes in today's quilts. Many quilts are now being made to be donated to charitable organizations for resale, or to be sold to quilt shops and gift stores, and these new markets have brought about a change in quilt sizes. With our queen- and king-sized beds, we need and want quilts that are larger than the old quilts. As the overall size has increased, so has the scale of the patterns, thus enlarging the neat, tight scale that is so appealing in older quilts.

In earlier quilts black was the background color generally used, with various shades of blue following in popularity. The pattern colors have also become lighter in tone, and even the use of printed fabrics is becoming common, except, of course, in those quilts made just for home use.

Amish quiltmakers today follow these new trends, and almost the only dark-colored, small-scale quilts now being produced are made under the direction of others for sale to outside communities.

The dark, graphic Amish quilt now seems to be a thing of the past, and if so, I was certainly offered a timely opportunity. This collection was never intended to represent only the finest and rarest examples, but instead, to show the widest possible variety of quilts produced in this area.

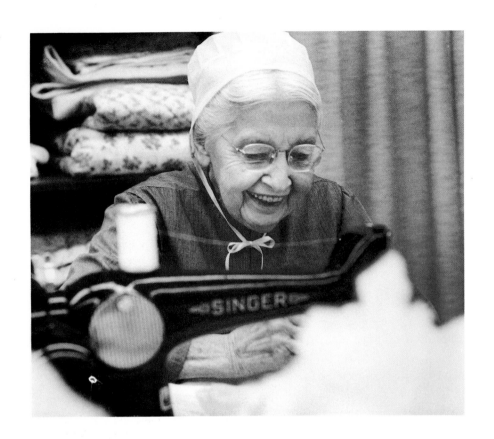

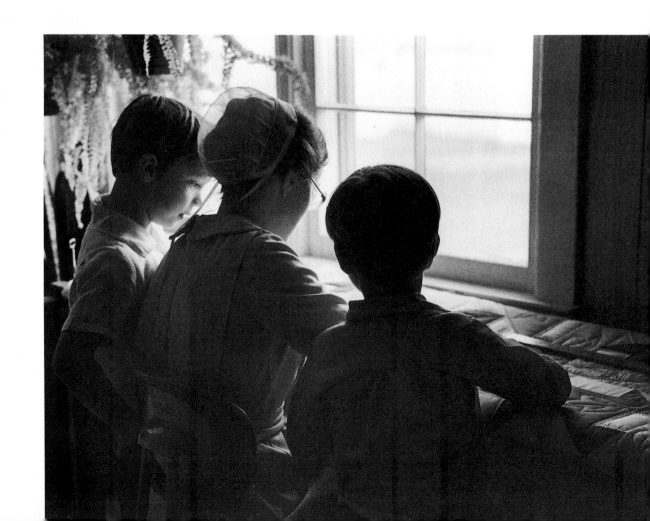

In 1977 the Bontragers traveled to my home in Michigan for a weekend visit. They brought news that the old general store down the road from their home in Honeyville was up for sale. Would I be interested in buying it and reopening the store, they asked, knowing I was becoming increasingly drawn to the area.

It was perfect timing. I was ready for a change in my life, and now I was being offered the opportunity to buy property and become a storekeeper in this very special community. But perhaps what attracted me most about this offer was the fact that the invitation came from a people whose very nature kept them from making such overtures to those who, like myself, are considered outsiders.

During the next few days I discussed the idea with my daughter, Charity, who agreed that it appeared to be an extraordinary opportunity. That next weekend we met with the owner, who still lived in the building, even though she had closed the store in 1964 when it had become too great a burden for a single person to manage. I also talked with some of her neighbors, who expressed the community's hope that the next owner would revitalize the general store and thus provide the locals with an alternative to the six-mile buggy ride to the nearest town.

Within two weeks I made the commitment to purchase the property, and soon after I sold my home in Michigan and moved to Indiana to begin reconstructing my living quarters and restoring the store to its original state.

The old store building sits on a beautiful triangle of three and one-half acres in an area called Honeyville, for once it was a center for beekeeping and honey production. Honeyville is still an almost exclusively Amish community, and in addition to the many Amish farms it contains a large, brick school, a feed mill, a metal fabrication plant, a blacksmith's shop, a repair shop for farm equipment, and a small sawmill. It is a quiet and very peaceful place with a nice feeling of community.

The original store building was constructed about 1850, but it had been destroyed by fire in 1902 and then rebuilt a year later. The present structure, although in need of repair, was intact, with living quarters in the rear.

I wanted to live in a completely contemporary space and at the same time keep the exterior of the building compatible with its surroundings. Mark Steele, my good friend and an architect, helped bring that about very successfully. Armed with his drawings, I spent the following eighteen months working

side by side with a local Amish builder, Lester Hochstetler, and his crew in completing the structure. My daughter, meanwhile, had been graduated from Goshen High School nearby, and we moved into our new home on Christmas Day, 1979.

Next came the problem of how to deal with the completely empty store space. In the months to come I was fortunate in finding a store in the nearby community of Scott that was built about 1900 and still retained all of its original shelving and counters. The old Haggerty Brothers store had been closed for years, and was being used as a small workshop by the present owner. I contracted to buy the majority of the fixtures and, along with Amos and Tim Rieman, removed them carefully and reinstalled them in the store in Honeyville. With the help of other friends, I was able to locate old lighting fixtures, showcases, a commercial wooden cooler, an ice-cream table and chairs, and a host of miscellaneous old fixtures, all of which fit compatibly to re-create the feeling of a small-town, turn-of-the-century store.

Then came the process of deciding just what to stock in a general store that would cater only to the needs of the Amish community. By this time it had been decided that Amos would close his repair shop and come to work managing the store. In addition, Edna Borkholder and Edna Weaver would work on an as-needed basis. The four of us, along with the help of many good suppliers, started placing our initial orders for groceries, drugs, fabric, notions, hardware, shoes, boots, men's pants and jackets, hats, cookware, paint, and so on. Although our quantity needs were relatively small, the variety was seemingly endless. When the goods started to arrive, it seemed like Christmas. Many of the neighbors and their children came to help with the unpacking, marking, and stocking. Day by day the empty space became filled until, finally, on October 10, 1980, Honeyville once again had a general store of its own.

So now there were no more long buggy rides to neighboring towns for supplies once a week. Instead, many of the Amish walk to the store each day. It is a place where the men and boys can play checkers, swap stories, and eat ice cream after a long day in the fields.

The Amish do not have churches, meetinghouses, or telephones, so the store, like the feed mill and the weekly stock auctions, becomes an important place in the community where things of local interest can be discussed. The Amish are not terribly interested in world or even national affairs. They learn of events that take place in other Amish communities through

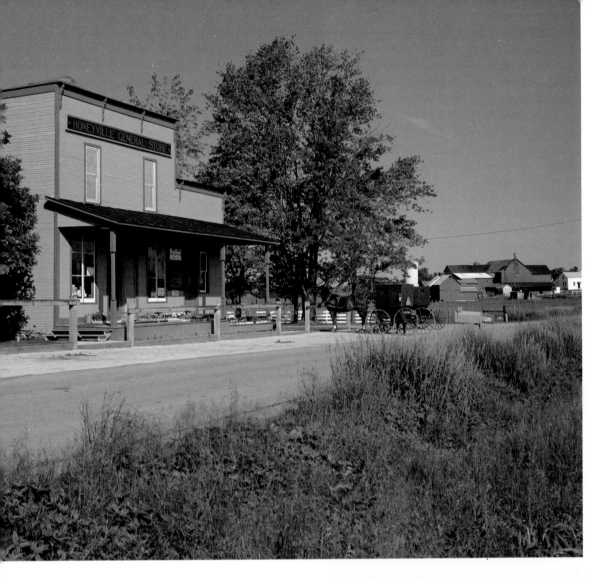
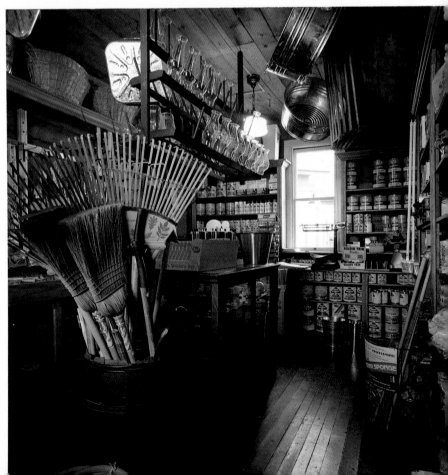

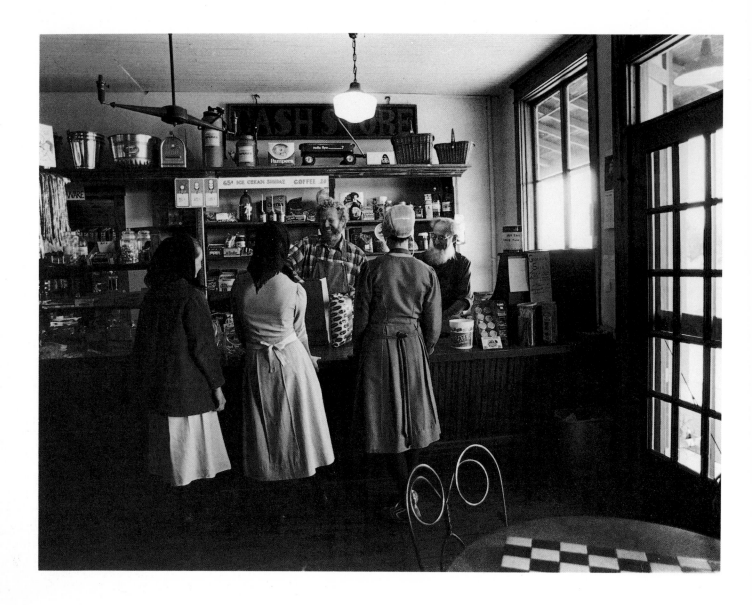

two weekly publications called *The Grit* and *The Budget*. By word of mouth they keep well informed about their own community and are eager and generous supporters of anyone in need. Just recently an auction was held to raise funds for Mel Eash, a young man in need of a kidney transplant. All the items that were sold at the auction were donated by local families, and although it was a miserable rainy day, these same people who so generously gave things to the sale stayed all day buyng other items they could use, and when the day was over $60,000 had been raised. The Amish do not purchase insurance, so this exceptional community spirit is essential if these families are to survive the occasional disaster. This same kind of support has been given to the store, for it was immediately apparent that the community was grateful for its reopening and was aware that it must be successful for it to survive.

Assembling this collection of Amish quilts and being so wholeheartedly accepted as a friend and neighbor in Honeyville have given me enormous pleasure. I am grateful to be able to share these experiences through this book.

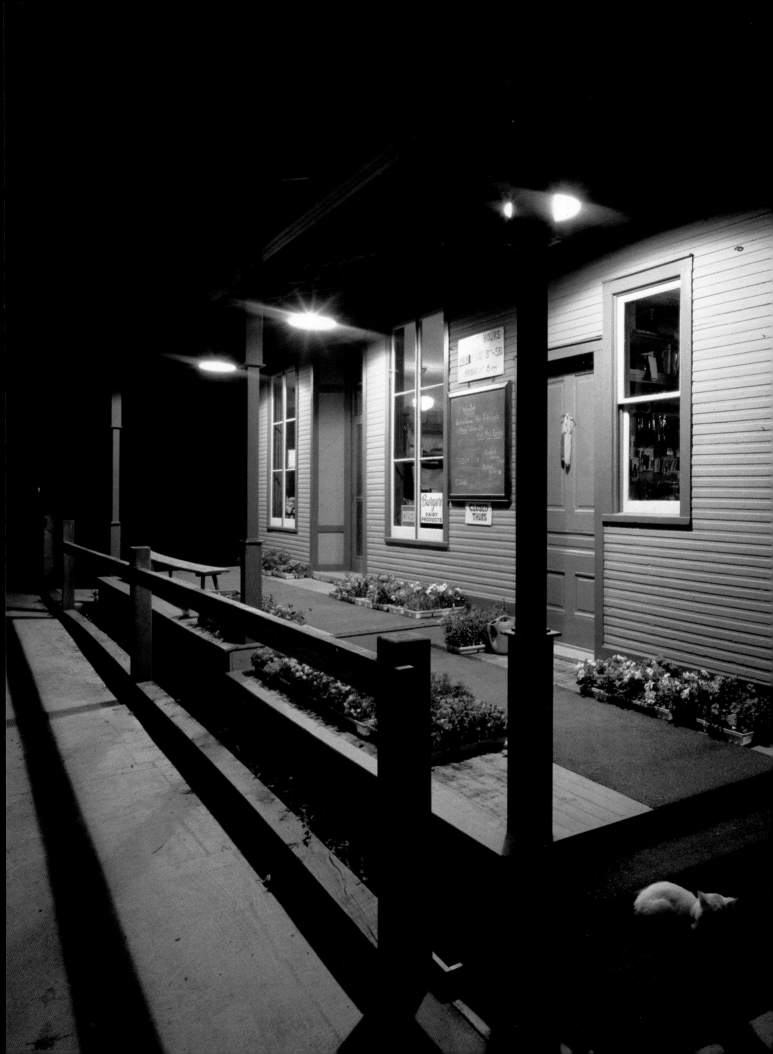

THE
COLLECTION

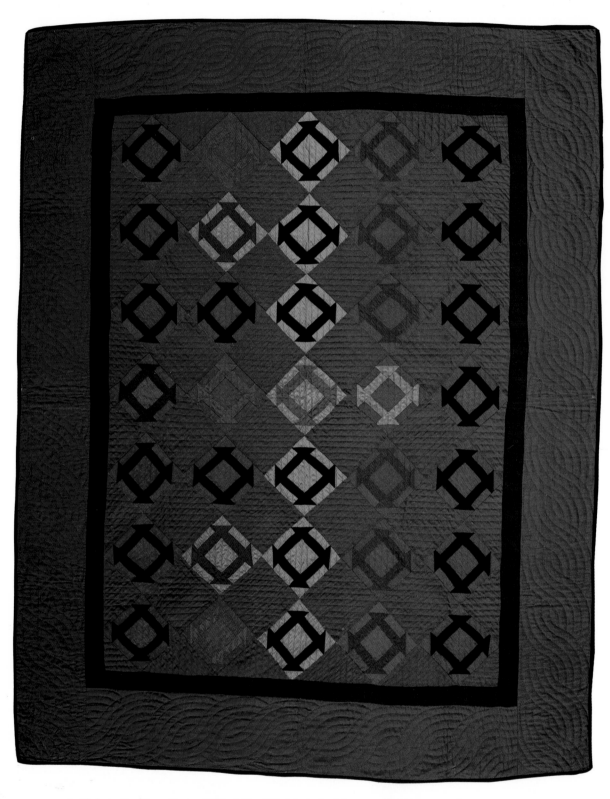

1. Hole in the Barn Door, 1905. 84″ x 65″. Made by Maryann D. Troyer and signed "M.D.T. 1905." Purchased from her stepson Robert Miller, Goshen, Indiana.

Note: Unless stated otherwise in the following captions, every quilt was made in Indiana, and every town mentioned is located in Indiana.

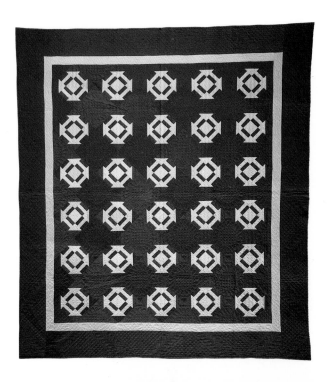

2. Hole in the Barn Door, 1930. 81″ x 72″. In 1930 Lydia Burkholder, with the help of her daughters Barbara and Maryann, made two identical quilts (pls. 2 and 3). The quilt in plate 2 was put in storage and never used, but the quilt in plate 3 was used as a bedcover for forty-five years. It is interesting to note how the color in plate 3 has faded and changed through the years of use.

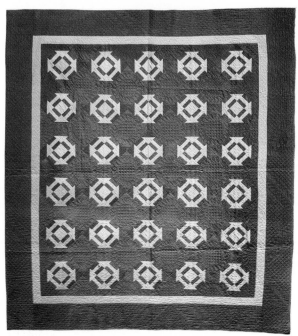

3. Hole in the Barn Door, 1930. 81″ x 72″.

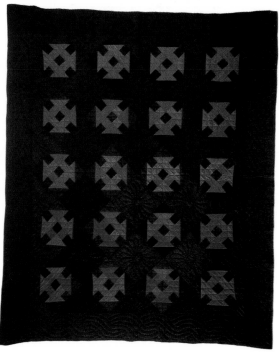

4. Hole in the Barn Door, Honeyville, 1935. 83″ x 69″. Dated and initialed in the quilting "January 1, 1935—E.B. age 20."

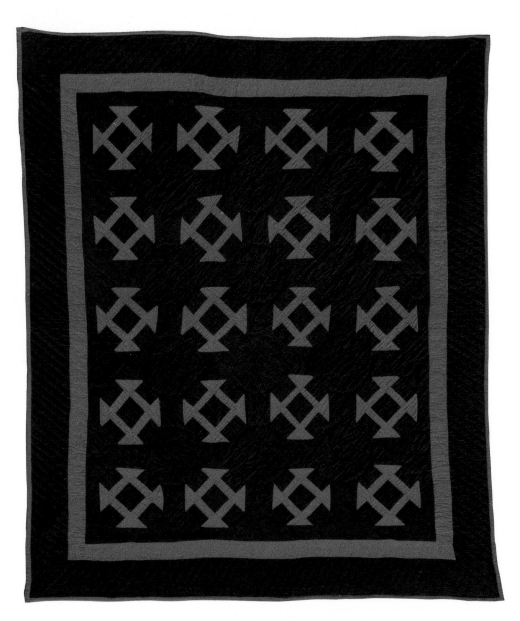

5. Hole in the Barn Door, Middlebury, c. 1900. 80″ x 67″. Made by Amanda S. Troyer. The red inside border is quilted with a continuous series of initials, presumably those of the maker's family and neighbors. Purchased from her son Elmer T. Miller.

6. Unnamed design, 1915. 92″ x 79″. Pieced by Mrs. Annie Miller and quilted by her daughter Katie, this quilt was made for Katie's daughter Susan (Mrs. Daniel C.) Beachy. The quilt is initialed S.D.M. and dated February 14, 1915, and was purchased from Susan Beachy, who was born in 1900 in Shipshewana, Indiana.

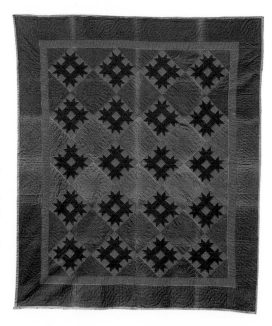

7. Hole in the Barn Door variation, Emma, 1943. 88″ x 72″. Made by Mrs. Menno Yoder for her sixth child, Cornelius M. Yoder. The quilt is initialed and dated in the quilting "C.M.Y. February 18, 1943." Mrs. Menno Yoder lived in Emma, Indiana, and during her lifetime she made forty-four quilts. Many of these were made for her seven children and were documented by quilting their initials and the date she began the quilting in the corners. Mrs. Yoder made seven black and yellow quilts like this one so that each child could have one. The collection contains three of these quilts—one made for Edna Yoder and dated February 5, 1935, one made for Levi M. Yoder and dated March 26, 1942, and this one made for Cornelius M. Yoder.

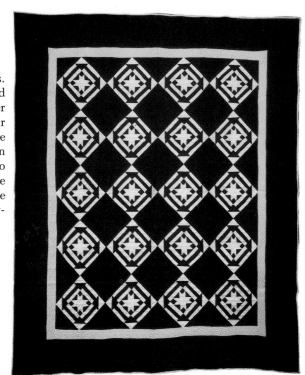

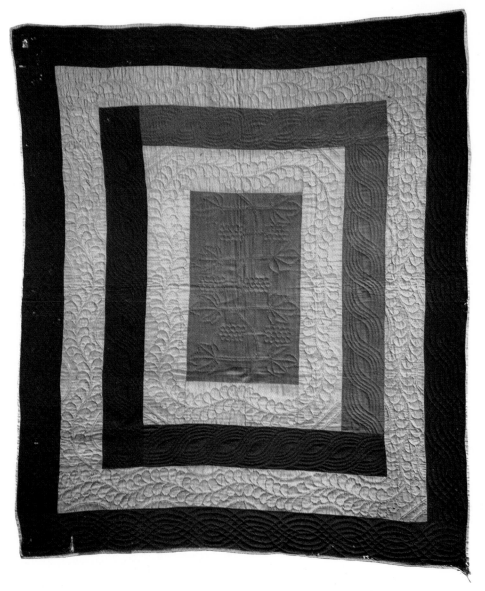

8. Center Frame, Honeyville, 1900–1910. 88″ x 74″. This unusual pattern is made particularly effective by the muted palette and the handsome quilting designs.

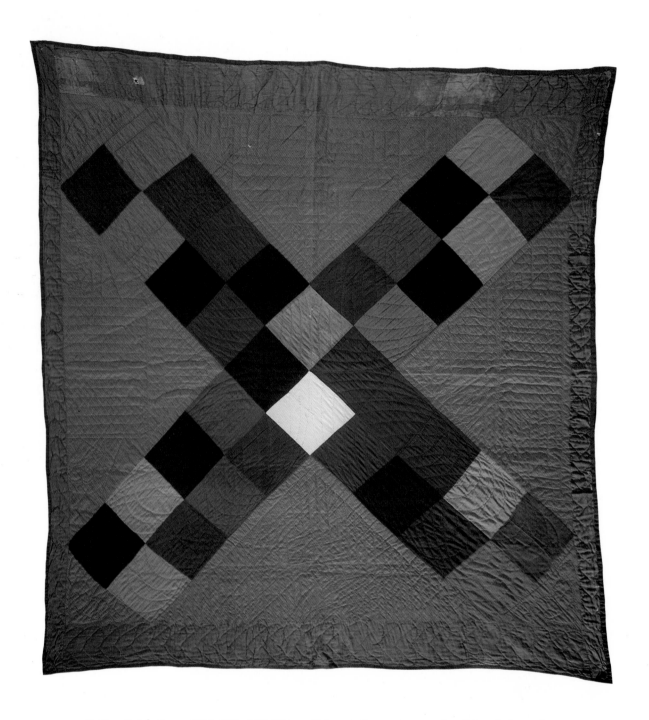

9. One Patch Cross, 1912. 80″ x 75″. This quilt boasts the most unusual quilting designs of any in the collection, for in the four large, red triangular areas are quilted the front and back of a house and the front and back of a barn. The date "1912" is quilted in the gable of the house. The sections showing the barn also include a horse, a cow, a sheep, a dog, and a doghouse. Hearts are quilted in the large crosses. This quilt descended in the family of George Brenneman, and it was purchased from his daughter Mrs. Mildred Stutzman in Honeyville.

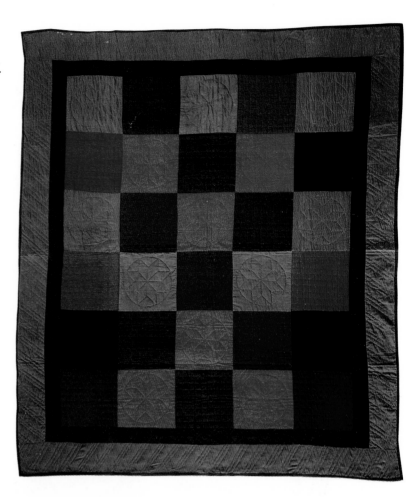

10. One Patch, 1920–1940. 76″ x 66″.

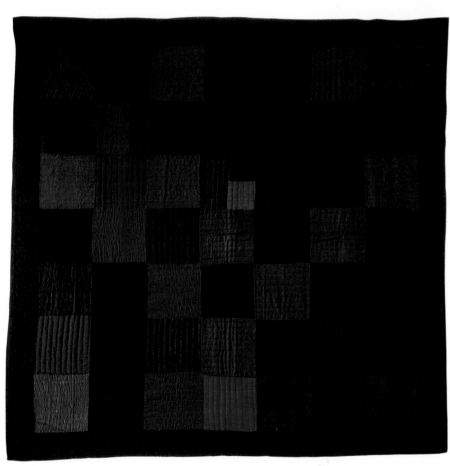

11. One Patch, Goshen, 1910–1930.
74″ x 74″. Made by Mary Miller.

25

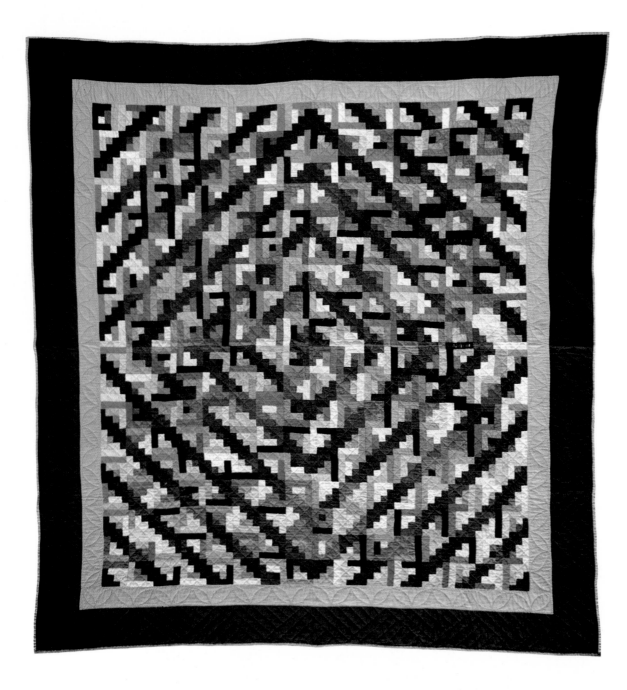

12. Log Cabin, Barn Raising design, Honeyville, 1920–1935. 76″ x 70″.

13. Log Cabin, Light and Dark design, Honeyville, c. 1920. 70½″ x 62″.

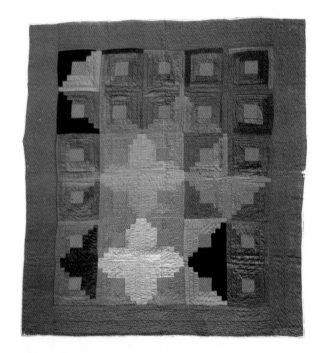

14. Log Cabin, Chevron design, Topeka, 1943. 83″ x 74″. Made by Mrs. Susie Miller and dated in the quilting.

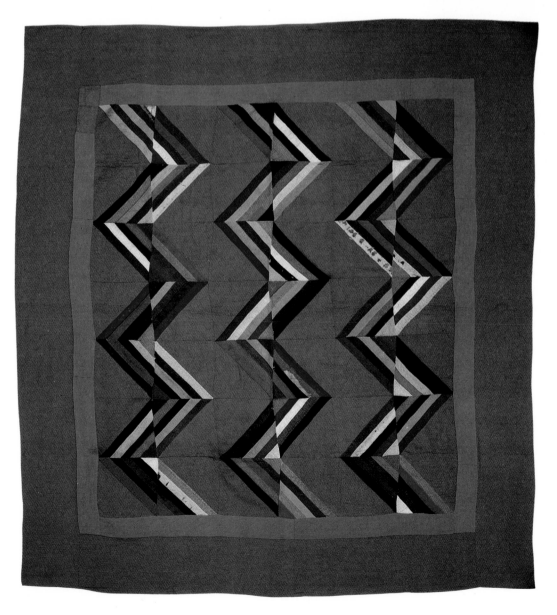

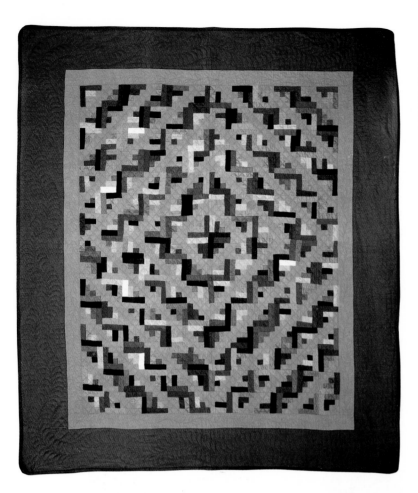

15. Log Cabin, Barn Raising design, Shipshewana, 1925. 82″ x 72″. Made by Mrs. Sam Schrock and her daughter Ada (Mrs. Will) Lambright and purchased from Mrs. Lambright.

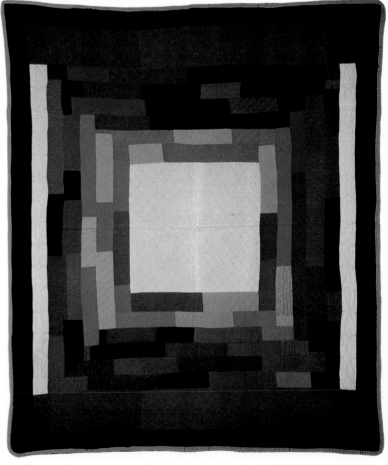

16. Central Square, Emma, 1915. 72″ x 60″. Made by Katie Greenawalt, this boldly designed quilt was obviously planned by the maker to use up some fabric scraps. It is one of the very few Amish quilts of original design known to me. The quilt was purchased from the maker.

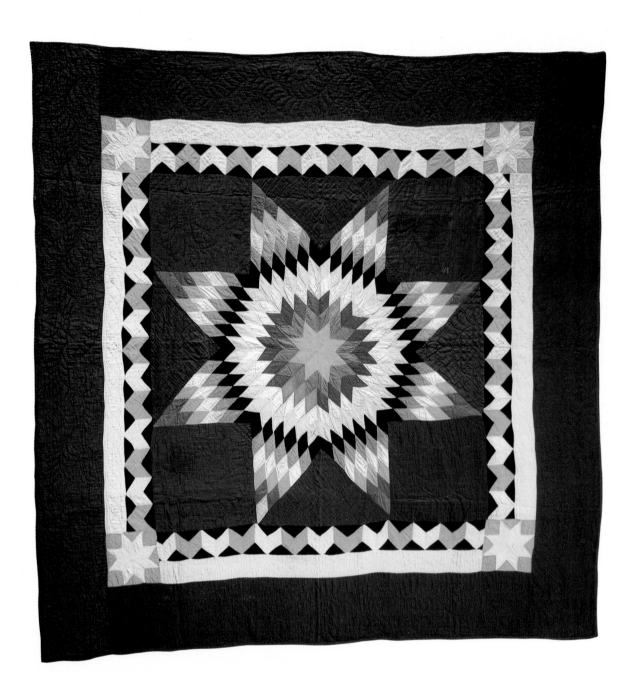

17. Lone Star, Honeyville, 1930. 79″ x 75″. Made by Amanda Yoder and her daughter Anna. The design of the inner border is unusual in an Amish quilt.

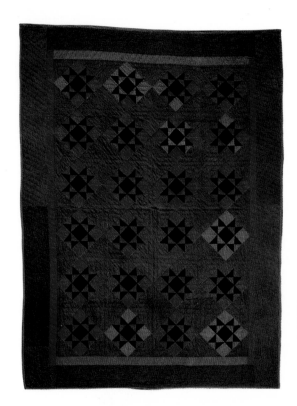

18. Evening Star, 1910–1925. 88″ x 74″.

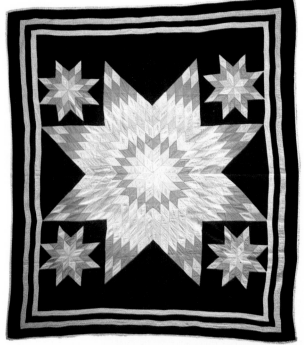

19. Star of Bethlehem, Middlebury, 1921. 82″ x
70″. Quilted above the central star are the initials "M.A.M." and the date "December 1921."

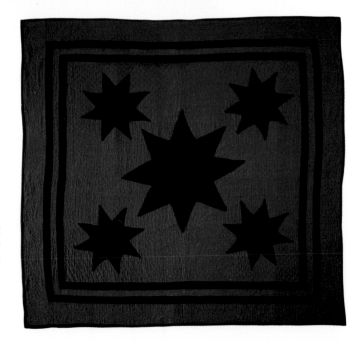

20. Stars, 1910–1920. 68″ x 68″. This quilt
descended in the family of Abner Miller, now
living in Topeka, and it was purchased from
him.

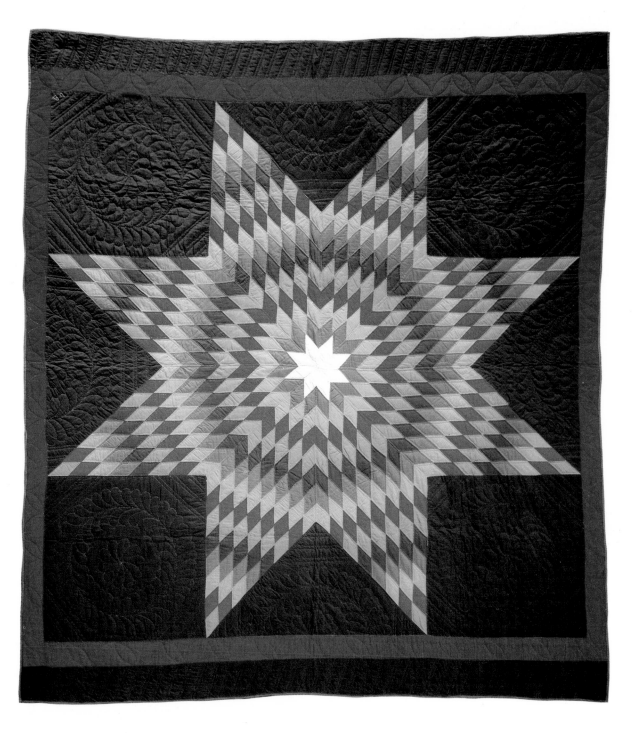

21. Lone Star, Emma, 1923. 84″ x 74″. Made for her husband by Mrs. David Bontrager.

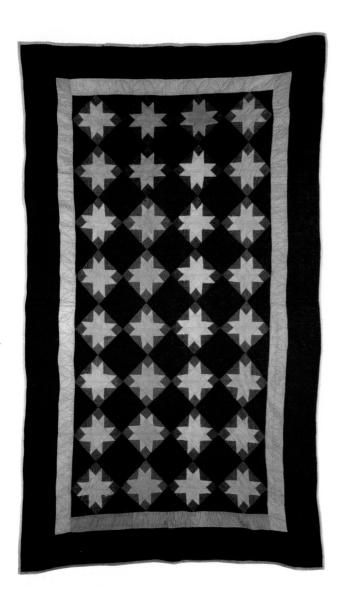

22. Variable Star, Topeka, 1916. 78″ x 45″.
Dated in the quilting, this piece descended in
the family of Abner Miller.

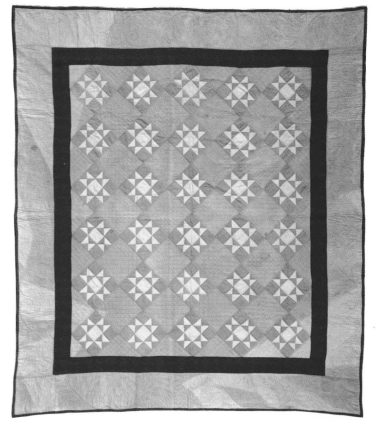

23. Eight-point Star variation, Honeyville, c.
1930. 80″ x 70″. Descended in the family of
Melvin J. Bontrager.

24. Ohio Star, c. 1910–1920. 72″ x 60″.

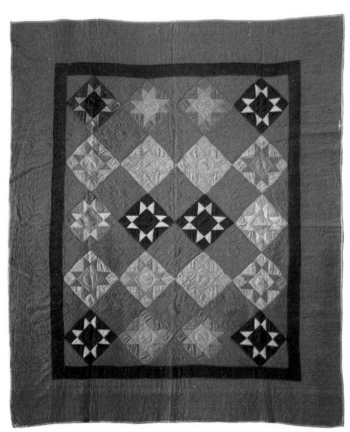

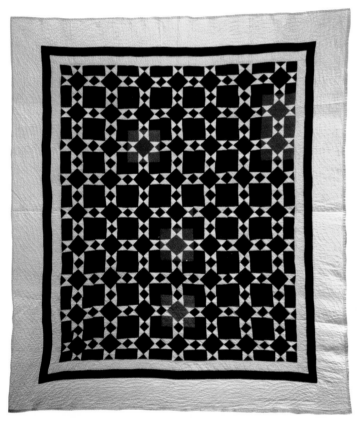

25. Evening Star, Elkhart, 1925–1935. 84″ x 72″.

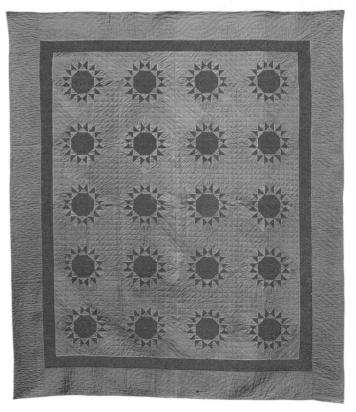

26. Sixteen-point Star, c. 1925. 81″ x 71″.

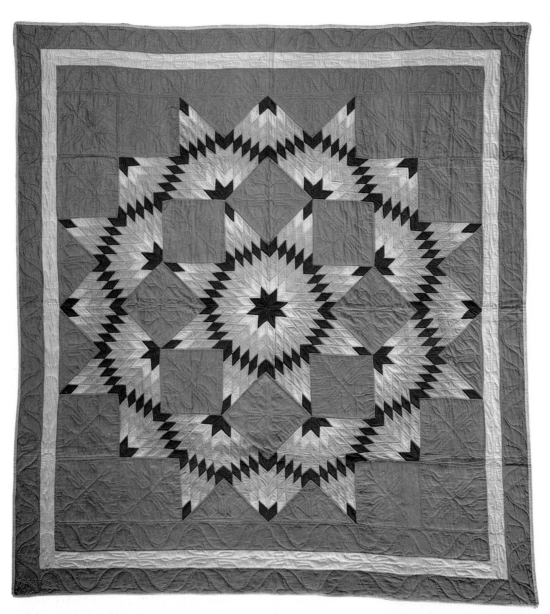

27. Broken Star, Haven, Kansas, 1926. 74″ x 68″. Made by Mrs. Clara Bontrager in Haven, Kansas, and purchased from her daughter in Topeka, Indiana.

28. Six-point Star, Honeyville, c. 1910. 73″ x 65″. Made by Mary (Mrs. John) Christner when she was living on the first farm west of the Honeyville store, and purchased from her youngest daughter, Mary, born in 1901, who still lives on the farm.

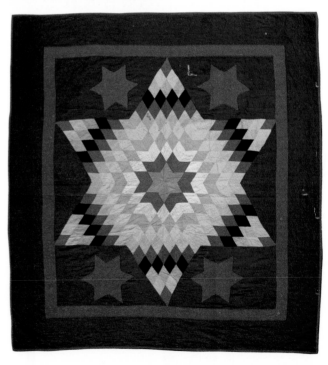

29. Single Irish Chain, 1920. 84″ x 50″. Used for a trundle or daybed, this quilt is made of cotton sateens.

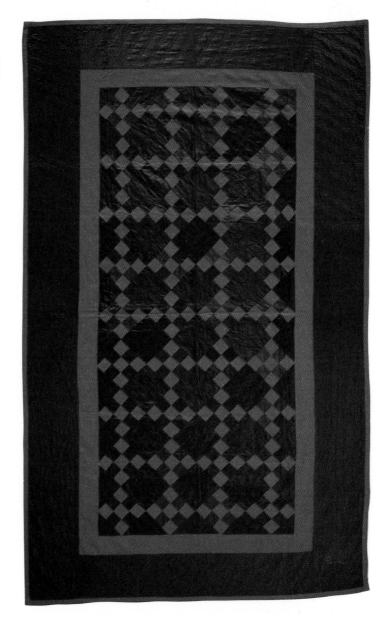

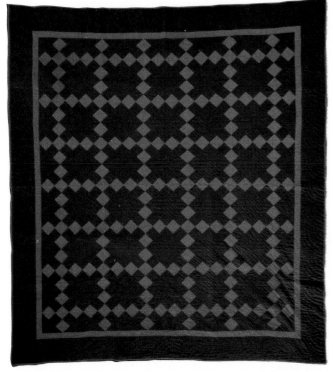

30. Single Irish Chain, Emma, 1931. 86″ x 76″. Made by Mrs. Susan Lambright and quilted by Mrs. David Weaver, this piece was made for Nina D. Hostetler, Mrs. Lambright's daughter. It is initialed and dated in the quilting "N.D.H. February 1931."

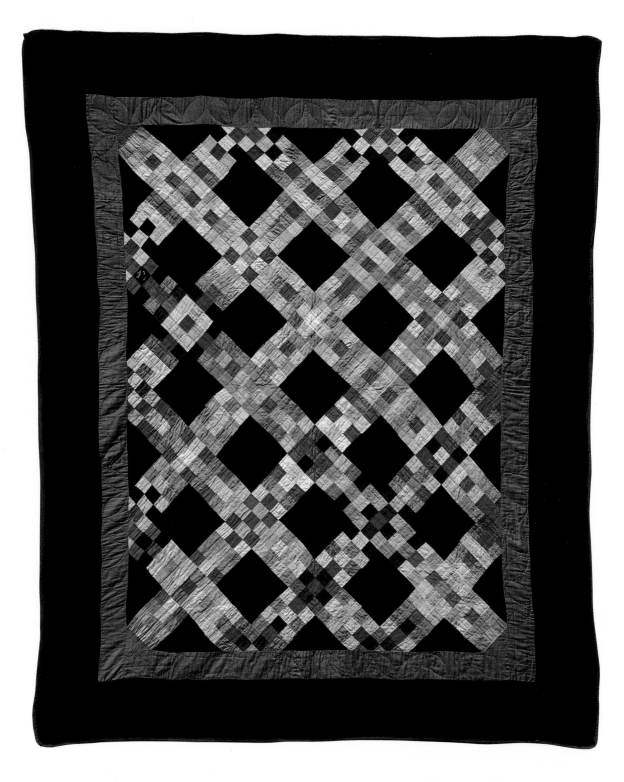

31. Irish Chain variation, Shipshewana, 1925. 83″ x 67″. Made by Lydia S. Whetstone, who married Ammon E. Bontrager. Purchased from their daughter Katie. Dated in the quilting.

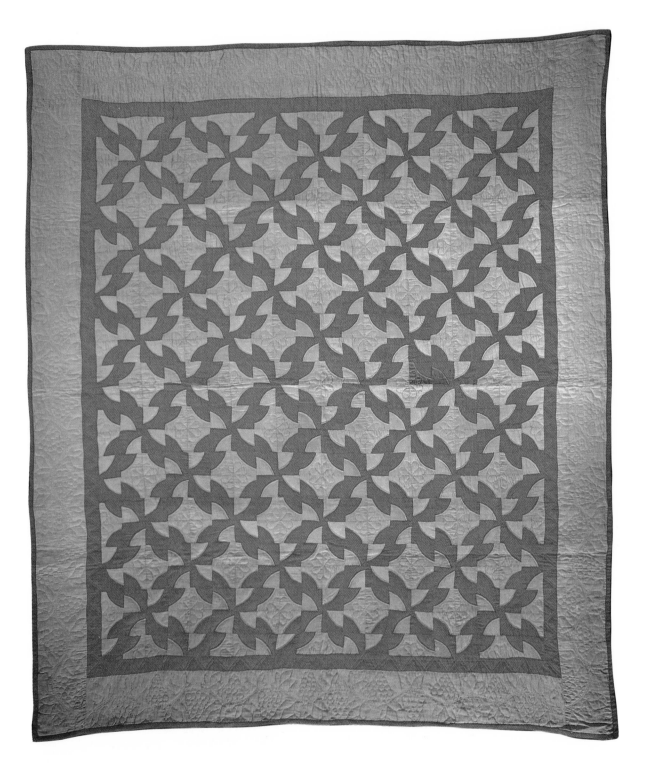

32. Solomon's Puzzle, 1915. 84″ x 70″. Dated and initialed in the quilting "J.J.K.M. 1915" and "L.D.M. February 11."

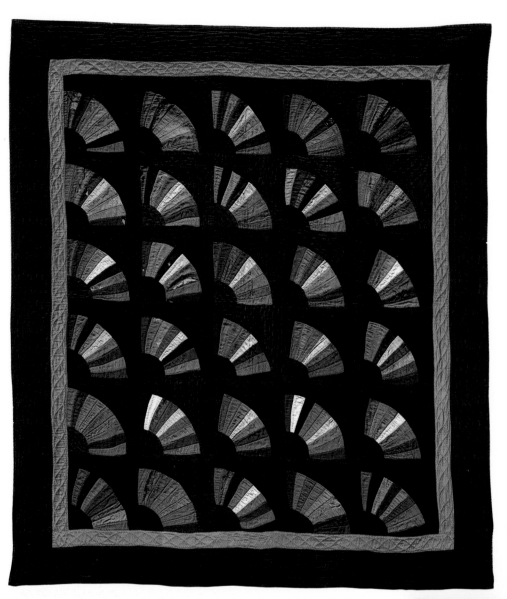

33. Fans, Middlebury, 1937. 80″ x 70″. Made by Anna (Mrs. Elmer T.) Miller and purchased from her husband.

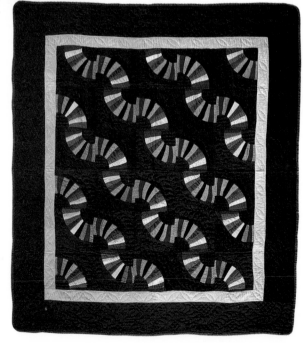

34. Fans, Honeyville, 1915–1930. 81″ x 69″.

35. Fans, 1920–1930. 82″ x 72″. Initialed "P.M." in the quilting.

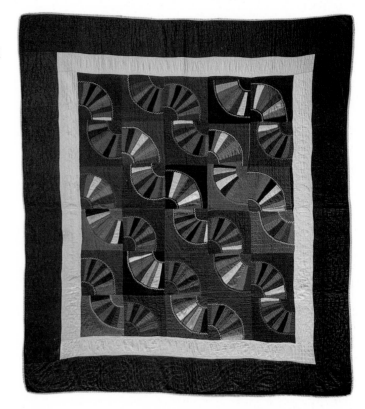

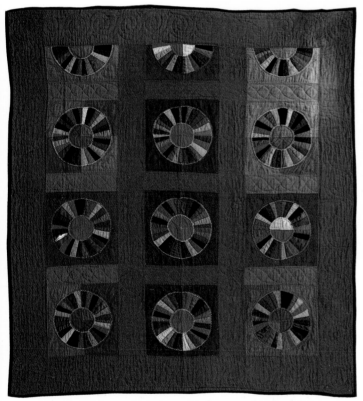

36. Fans variation, 1936. Purchased from Mrs. Menno Lambright, Middlebury.

37. Fans, Shipshewana, 1934. 84″ x 75″. Made by Lydia S. Whetstone shortly before her marriage to Ammon E. Bontrager. Purchased from their daughter Katie.

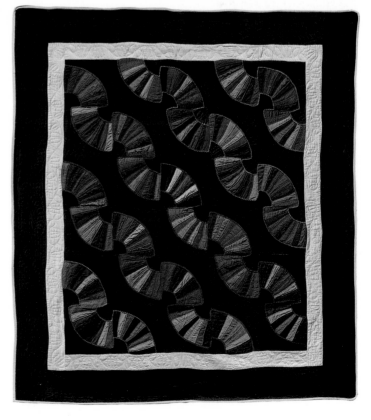

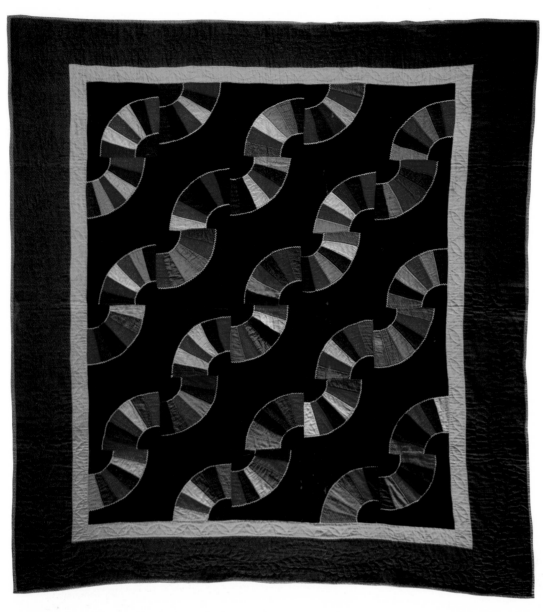

38. Fans, Honeyville, c. 1920. 76″ x 72″. Made by Lydia (Mrs. Joseph) Bontrager. Purchased from her son Milo J. Bontrager.

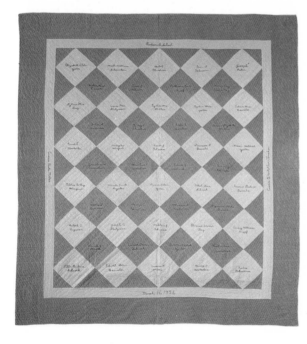

39. Album, Honeyville, 1926. 77″ x 71″. Made by Annie Viola Miller and purchased from her. The quilt contains the name of the maker's school, the schoolmaster, her schoolmates, her name, and the date March 16, 1926.

40. Honeycomb, Shipshewana, 1925. 78″ x 78″. Made by Mrs. Sam Schrock and purchased from her daughter, Mrs. Will Lambright.

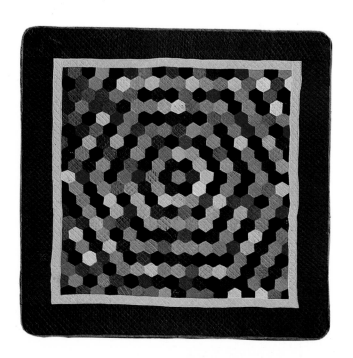

41. Baskets, 1930. 82″ x 78″. Dated "April 19, 1930," in the quilting.

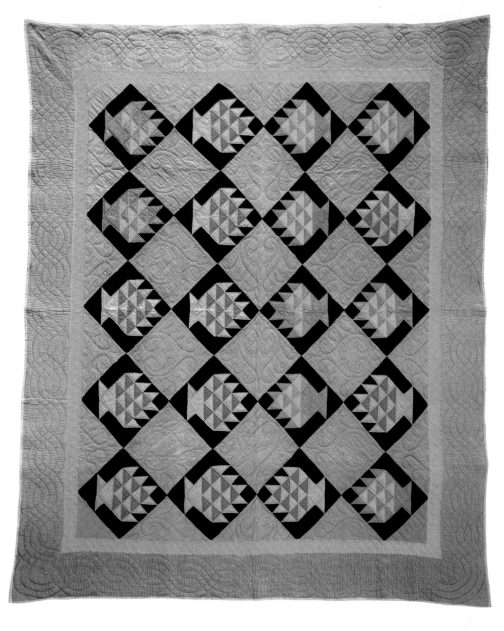

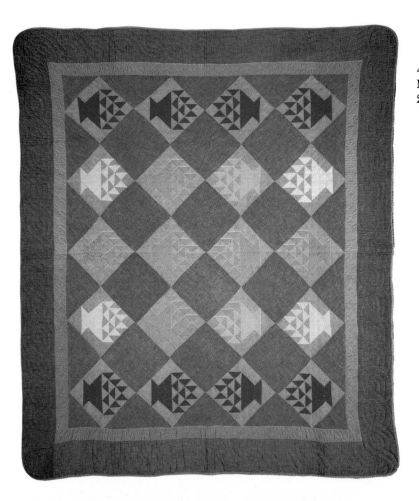

42. Baskets, Shipshewana, 1934. 80″ x 68″. Made by Mrs. Eli Bontrager and dated "March 22, 1934," in the quilting.

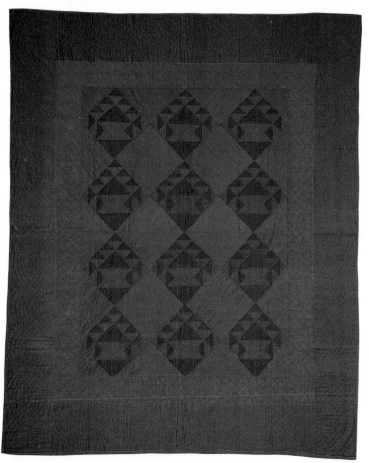

43. Flower Baskets, Honeyville, 1925. 78″ x 64″. Made by Mrs. Mose V. Yoder and her daughter Katie. Katie married Monroe J. Miller in 1922, and the quilt is initialed "K.M.M." "M.J.M." and is dated "March 11, 1925." The quilt was never used and was purchased from Monroe Miller in 1982, two years after his wife's death.

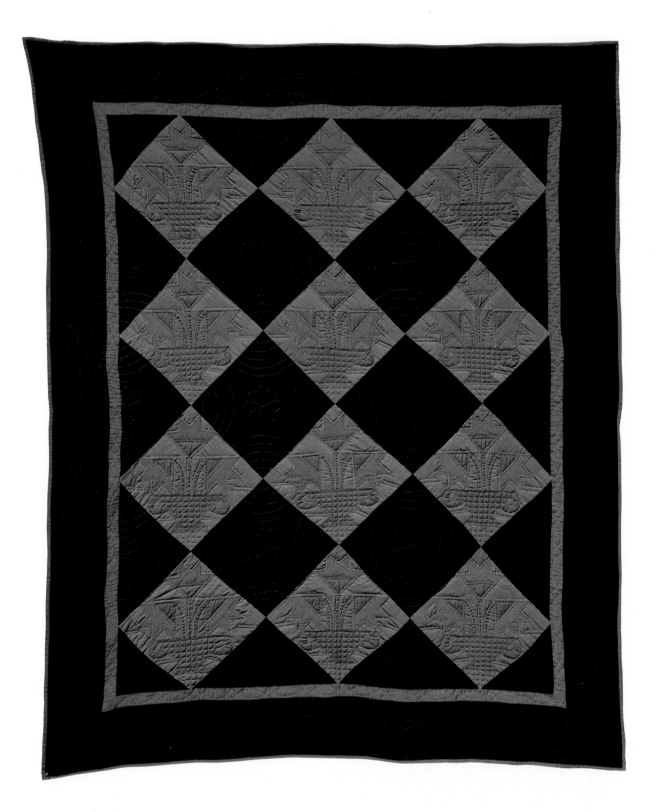

44. Pot of Flowers, Honeyville, 1937. 87″ x 70″. Made by Mary (Mrs. Manas) Hochstetler and dated "March 16, 1937." The quilt was never used and was purchased from Mrs. Hochstetler.

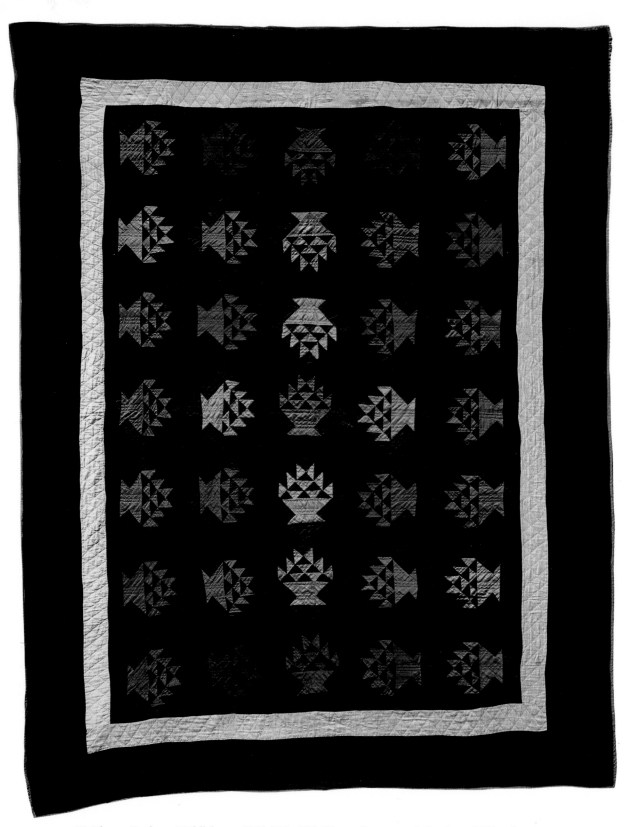

45. Flower Baskets, Middlebury, 1917. 88″ x 70″. The quilt was made by Anna Miller the year that she married Elmer T. Miller and was purchased from her husband.

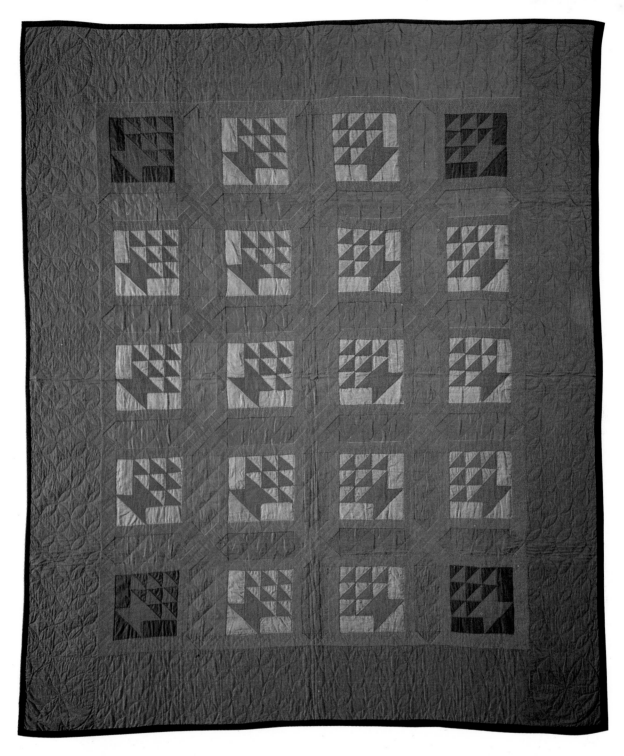

46. Flower Baskets in a Garden Maze, Topeka, 1925. 82″ x 67″. Pieced by Mrs. Joe S. Hostetler, Topeka, and quilted by Mary Frye, Haven, Kansas.

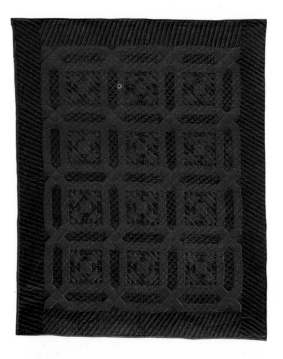

47. Garden Maze, Emma, 1935. 84″ x 78″. Made by Mrs. Menno Yoder and her daughter Edna Schlabach. Purchased from Edna Schlabach.

48. Ocean Waves, Topeka, 1922. 84″ x 79″. Made by Anna (Mrs. Urias V.) Yoder for her only daughter, Elizabeth (Mrs. Daniel J.) Miller.

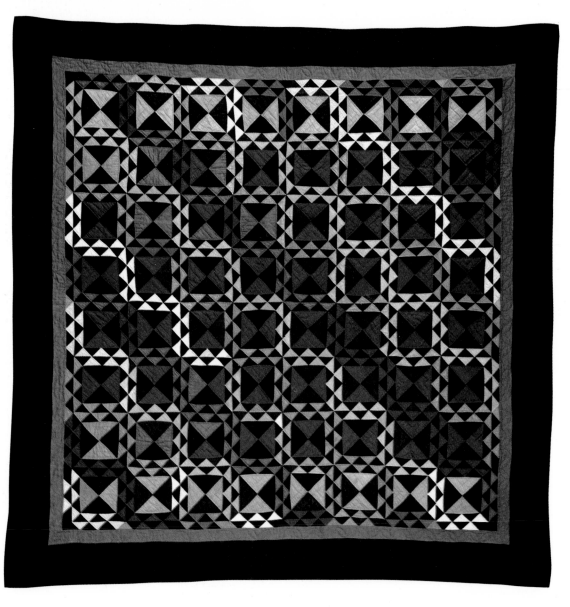

49. Ocean Waves variation, Middlebury, 1928. 86″ x 72″. Made by Amanda Sunthimer Yoder, this quilt was never completed, for it lacks the binding around the outside border.

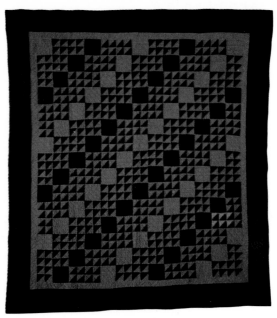

50. Ocean Waves variation, Emma, 1925. 82″ x 72″. Made for Nina D. Hostetler and purchased from her.

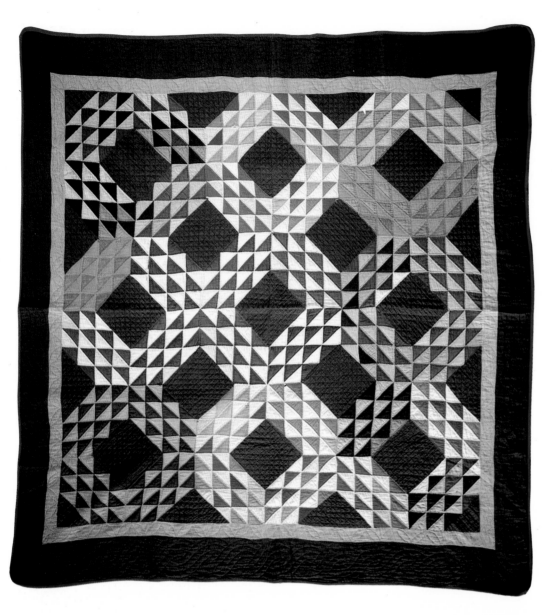

51. Ocean Waves, Honeyville, 1930. 84″ x 80″. Made by Anna Yoder.

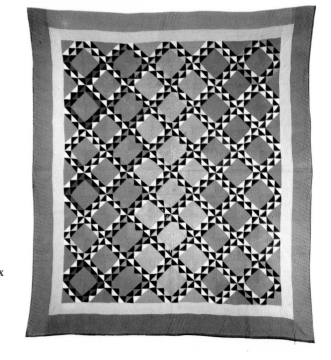

52. Ocean Waves, Middlebury, 1930. 80″ x 68″. Made by Lydia Eash.

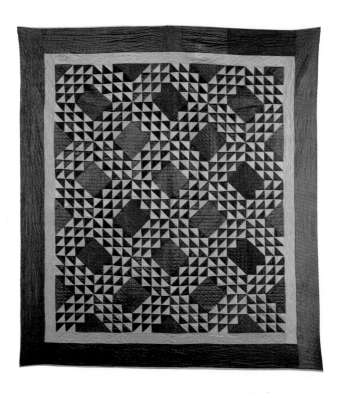

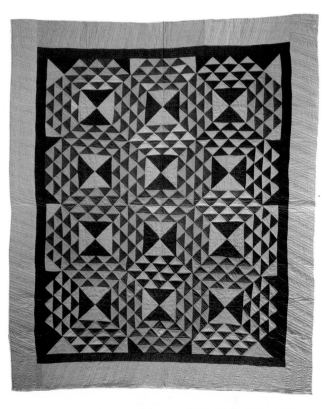

53. Ocean Waves, Emma, c. 1937. Made by Mary Mishler and her daughter Lydia Ann (Mrs. Abner) Miller. Purchased from Lydia Ann in Topeka.

54. Ocean Waves variation, 1930–1940. 86″ x 70″.

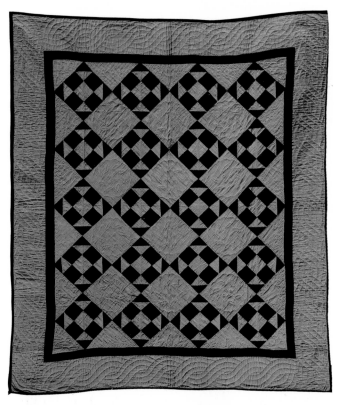

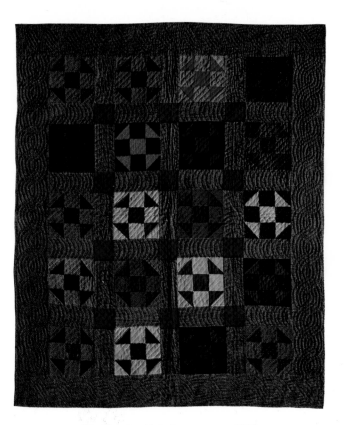

55. Shoofly, Middlebury, c. 1920. 80″ x 70″. Made by Amanda S. Troyer and purchased from her son Elmer T. Miller. The quilt contains eighteen sets of initials, some of which have been identified as the maker's brothers and sisters; the rest probably identified her neighbors.

56. Shoofly, Shipshewana, c. 1925.

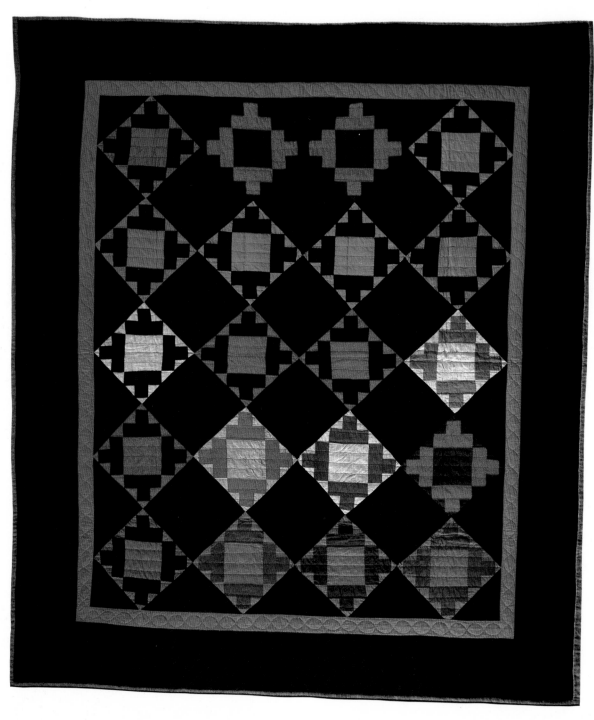

57. Album variation, Middlebury, c. 1900. 84″ x 73″. Made by Barbara Mast and purchased from her granddaughter, Susie (Mrs. Dan) Miller.

58. Tumbling Blocks, Topeka, 1930. 82″ x 71″. Made by Mrs. Manuel Herschberger and purchased from her daughter Mrs. Yost Lehman.

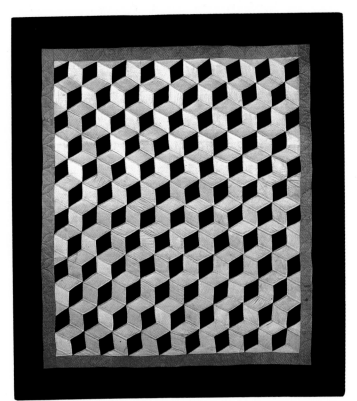

59. Tumbling Blocks, Elkhart, 1910. 82″ x 66″. Made by Mrs. Ed Lantz.

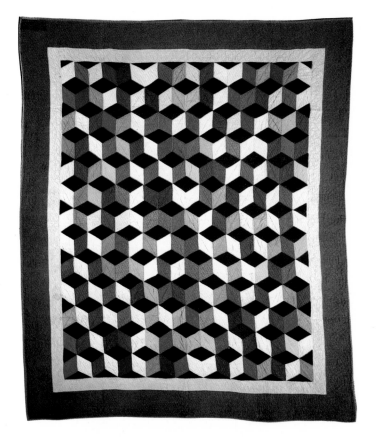

60. Sunshine and Shadow, Honeyville, 1930. Made by Amelia Yoder and her daughter, Leana. Although it is very popular in the Amish communities of Pennsylvania, this pattern is little used in Indiana.

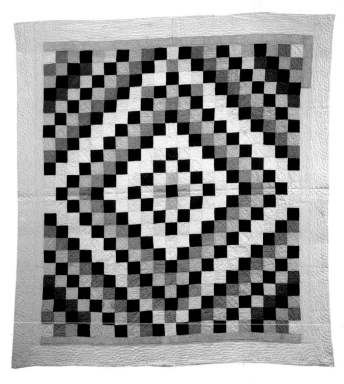

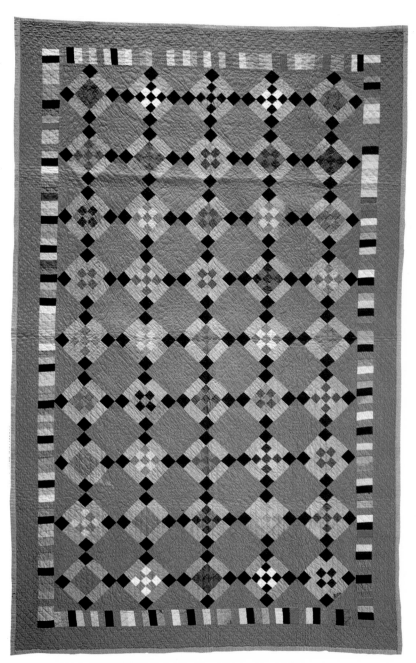

61. Nine Patch variation, 1915–1925. 80″ x 48″. The brown background and tight scale of this daybed- or trundle-size quilt made it a most desirable piece.

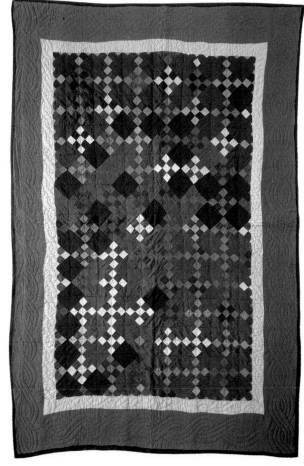

62. Nine Patch, 1930. 85″ x 53″.

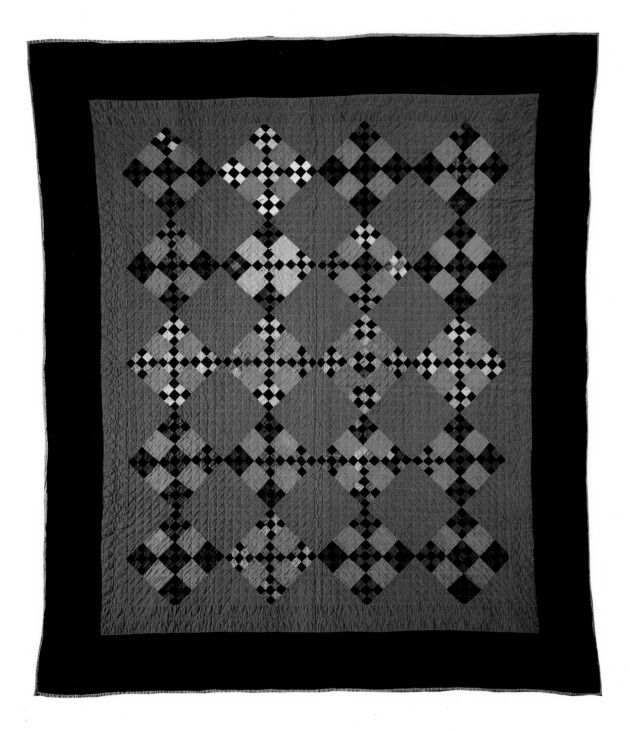

63. Double Nine Patch, Topeka, 1900–1920. 80″ x 68″.

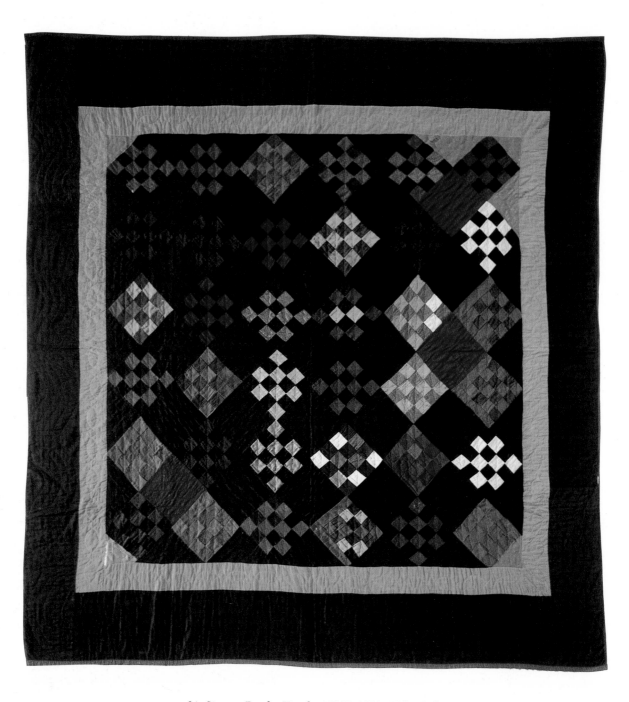

64. Sixteen Patch, Topeka, 1920–1930. 76″ x 65″.

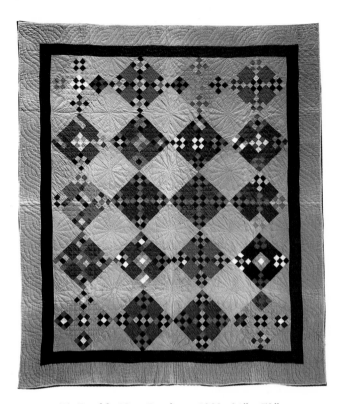

65. Double Nine Patch, c. 1920. 84″ x 70″.

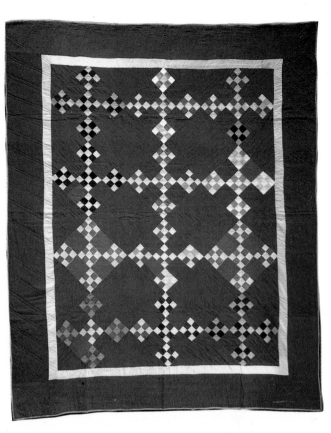

66. Double Nine Patch, Topeka, 1920. 78″ x 64″. Made by Mrs. Elizabeth Lambright.

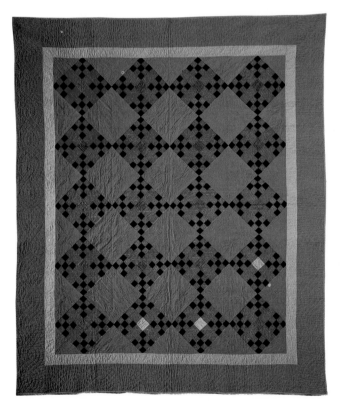

67. Nine Patch Cross, c. 1925. 79″ x 65″.

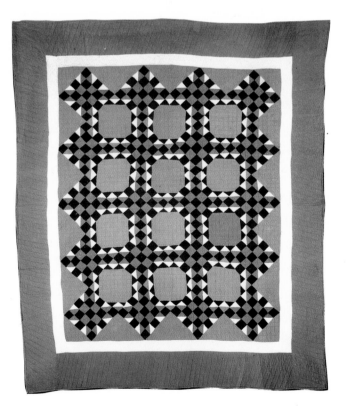

68. Twenty-five Patch variation, Middlebury, 1930. 80″ x 67″. Made by Mrs. Lydia Bontrager.

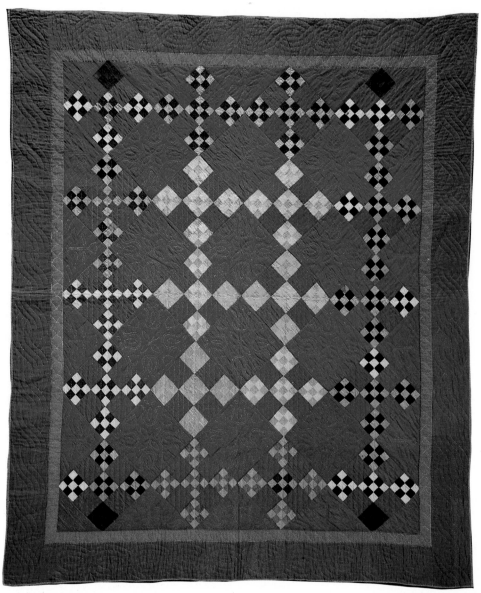

69. Double Nine Patch, Topeka, 1923. 92″ x 74″. Dated in the quilting "April 5, 1923."

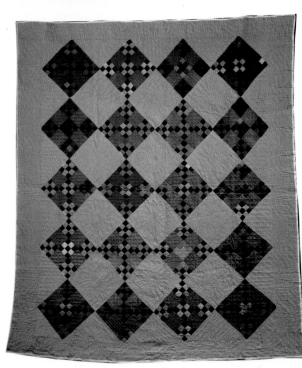

70. Double Nine Patch, Shipshewana, 1935. 84″ x 70″. Made by Mrs. Eli Bontrager and dated and initialed in the quilting "November 2, 1935—Age 21—L.B."

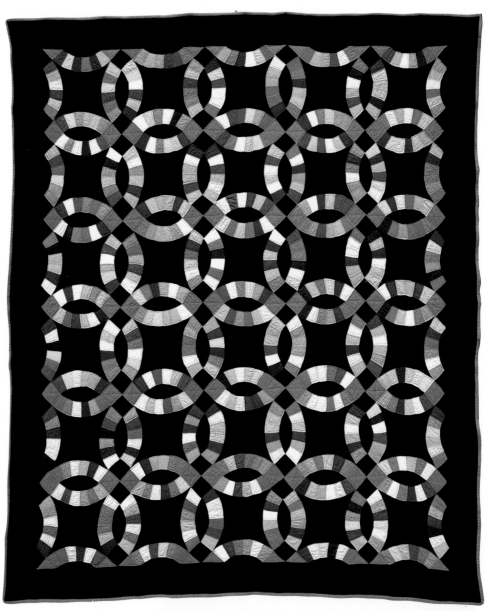

71. Double Wedding Ring, Topeka, 1940. 96″ x 76″.
Made by Mrs. Samuel Petershime.

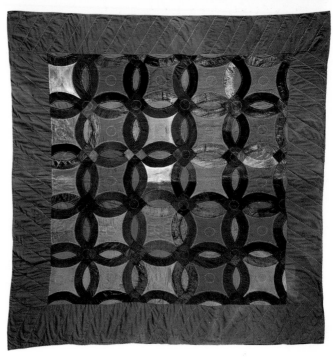

72. Double Wedding Ring, 1976. 88″ x 84″.
Made by Millie Raber, who is both a quilt-
maker and a suitmaker. This quilt was made
out of scraps of silk coat linings. When I first
saw this quilt, it was in Millie Raber's garden
protecting celery plants from an early frost.
Thus the piece is always known as "The Celery
Patch Quilt."

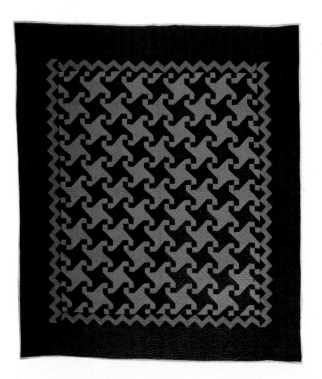

73. Indiana Puzzle, 1915–1930. 82″ x 70″. This pattern was borrowed by the maker from an "English" neighbor.

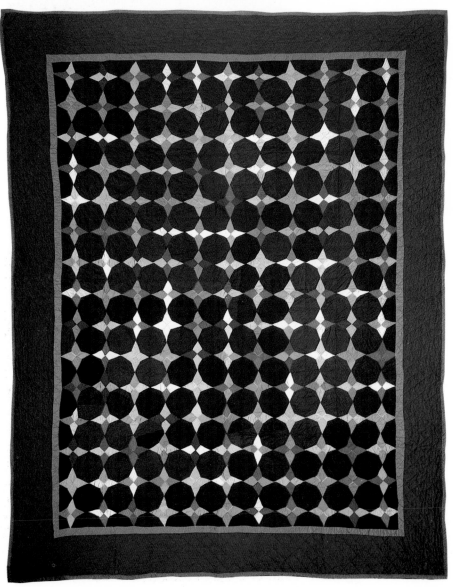

74. Black Hummingbird, Shipshewana, 1925. 88″ x 66″.

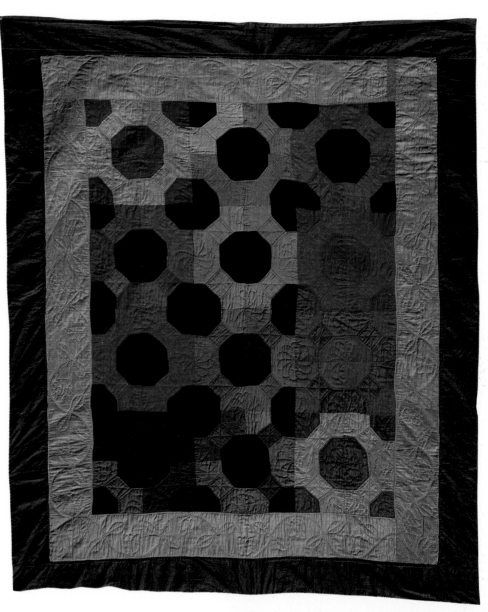

75. Bow Tie, c. 1925. 80″ x 65″. Made by Anna Miller and purchased from her husband, Elmer T. Miller.

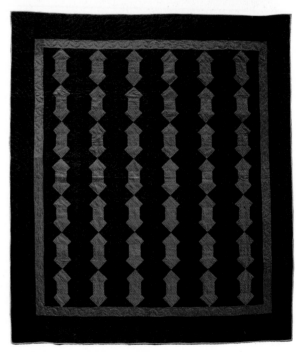

76. Bow Tie, Topeka, c. 1930. 85″ x 74″.

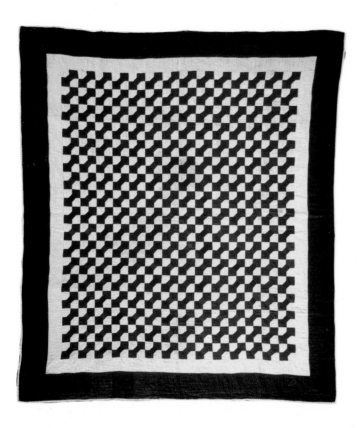

77. Bow Tie, Haven, Kansas, 1926. 84″ x 75″.
Made by Mrs. Clara Bontrager.

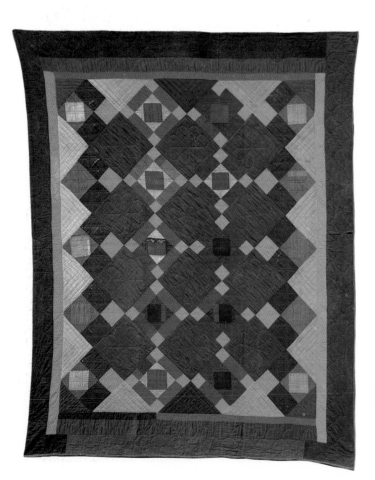

78. Bow Tie variation, 1875. 81″ x 64″. Made by Fanny
Yoder for her daughter Elizabeth. The quilt is initialed
and dated "F.Y.—E.Y. 1875," which makes this piece the
earliest documented quilt in the collection. It was pur-
chased from Fanny's great-granddaughter, Ida (Mrs.
Calvin) Lambright, who lives in Topeka.

79. Unnamed pattern, c. 1875. 85″ x 65″.
Made by Lydie Yoder, this quilt, which is one
of the earliest pieces in the collection, was pur-
chased from her granddaughter, Mrs.
Nathaniel A. Miller, in Lagrange.

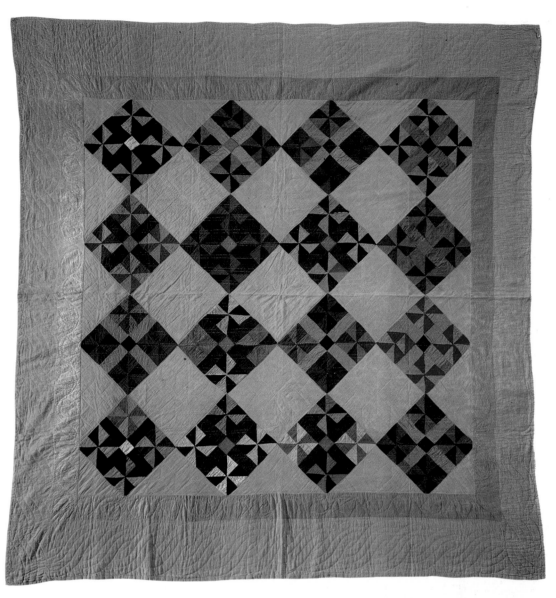

80. Pinwheel Four Patch with Cross, Haven, Kansas, 1920. 76″ x 70″. Made by Mrs. Sarah Miller.

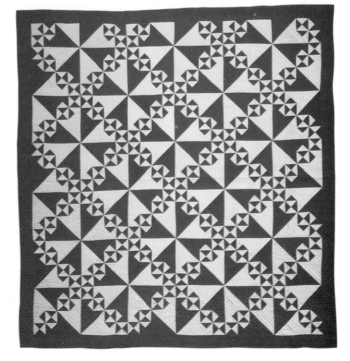

81. Pinwheel variation, Kokomo, c. 1935. This quilt, which was never used, descended in the family of Melvin J. Bontrager.

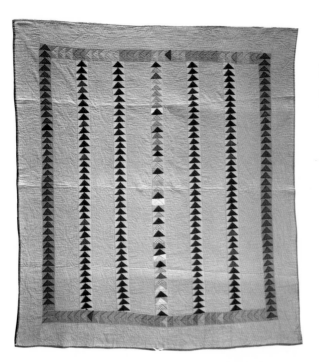

82. Wild Goose Chase, 1910–1925. 74″ x 62″. The particular interest of this quilt is the use of some printed fabrics, which is very rare indeed in Amish quilts.

83. Wild Goose Chase variation, Kansas, 1920. 82″ x 71″. Made by Clara Coon and purchased from her daughter in Topeka.

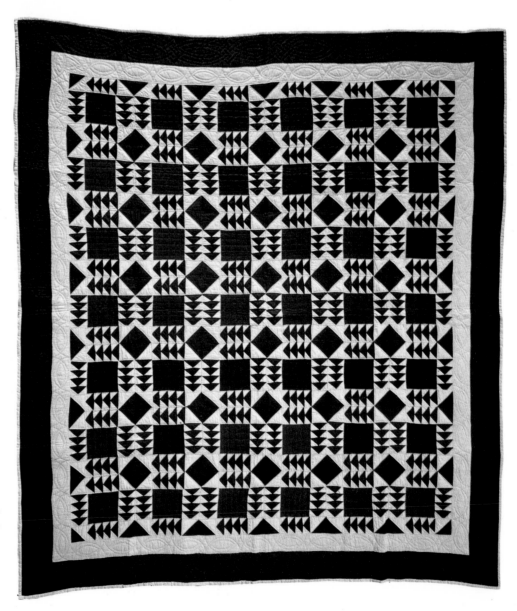

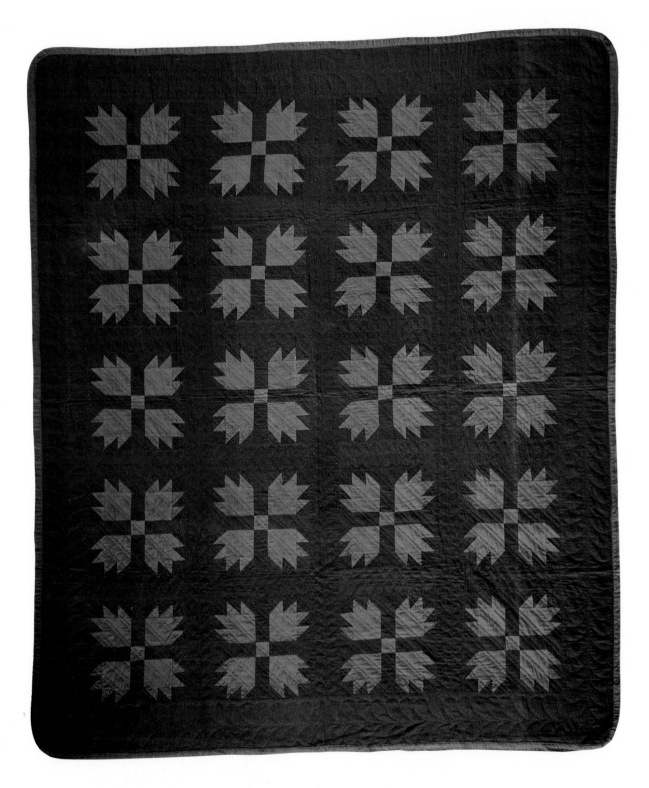

84. Bear's Paw, 1910–1920. 84″ x 68″. Purchased from Mr. and Mrs. Henry Yoder, the parents of Bertha (Mrs. Amos) Bontrager.

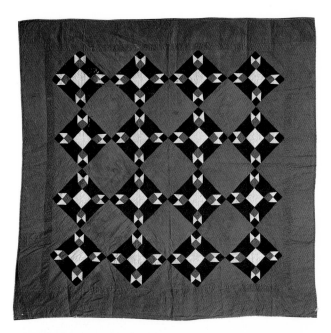

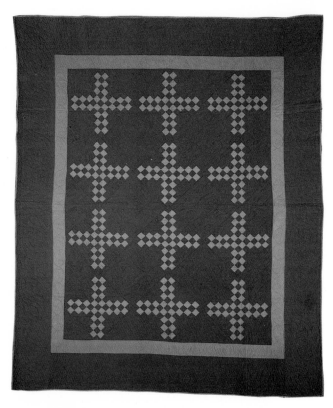

85. Rabbit's Paw, Honeyville, 1901. 75″ x 75″. Made by Mary (Mrs. Manas) Hochstetler at the time of her wedding. The quilt is initialed "M.H." and dated "1901," the year of her birth, and "1919," the year she was married. The quilt was purchased from Mary Hochstetler in 1981 at her home, which is the first farm west of the Honeyville store.

86. Unnamed design, 1925–1935. 84″ x 66″.

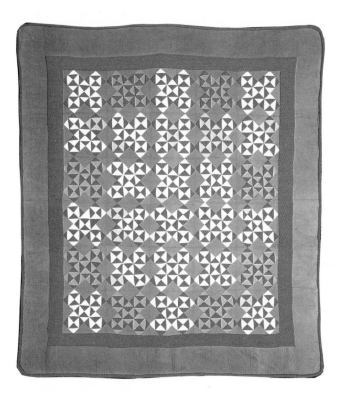

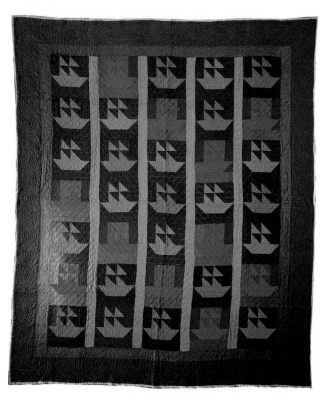

87. Hourglass variation, Topeka, 1915. 72″ x 64″. Made by Mrs. Daniel J. Yoder.

88. Sailboats, Topeka, 1960. 85″ x 71″. Made by Mrs. Amanda Lehman. This is an unusual pattern for the Amish.

89. Double Inside Border, probably
Ohio, 1910–1925. 86″ x 67″.

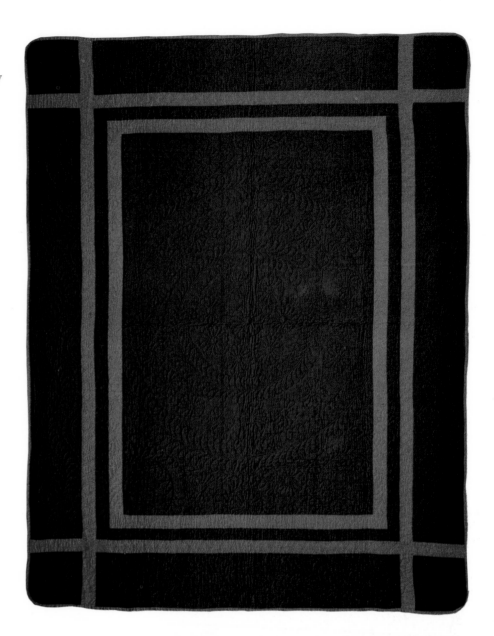

90. Zigzag, Hutchinson, Kansas, 1930. 79″ x
77″. Made by Mrs. S. N. Miller.

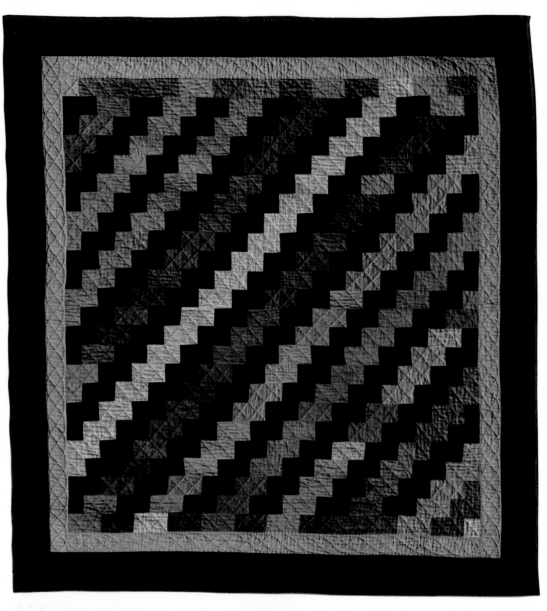

91. Stair Steps or Brick Wall, Emma, 1940. 85″ x 78″. Made by Polly Miller and purchased from her daughter Elizabeth Hostetler.

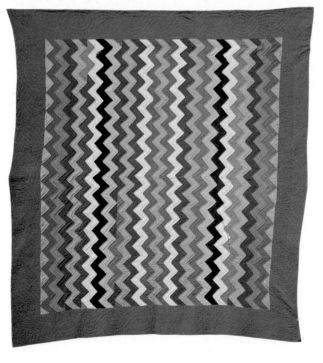

92. Streak of Lightning, Nappanee, c. 1940. 85″ x 76″. Made by Katie Hochstetler and purchased from her daughter Esther (Mrs. Joseph) Schmucker.

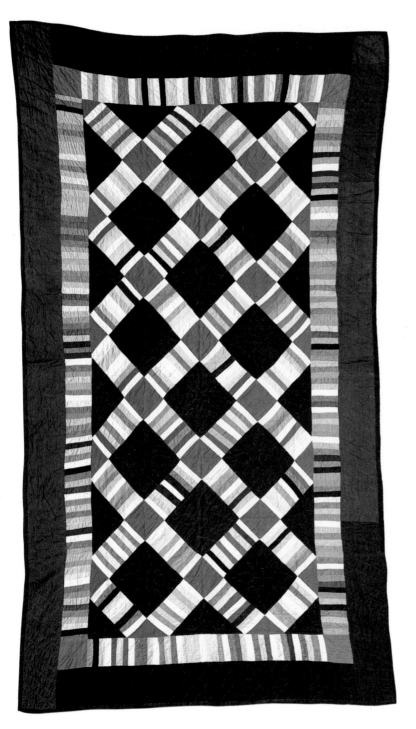

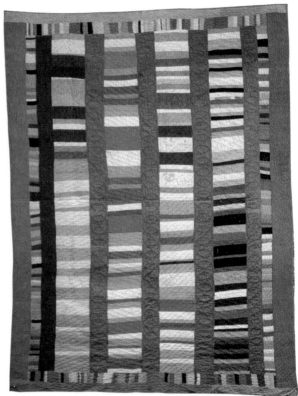

94. Chinese Coins, Haven, Kansas, 1935. 82″ x 61″. Made by Mrs. Sarah Miller.

93. Railroad Crossing, Topeka, 1930–1940. 77″ x 41″.

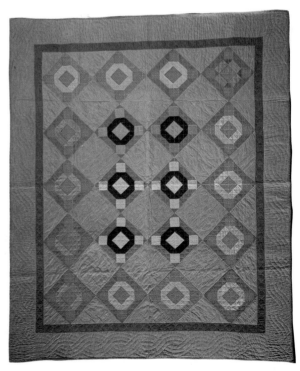

95. Unnamed design, dated in the quilting "July 19, 1934." 84″ x 70″.

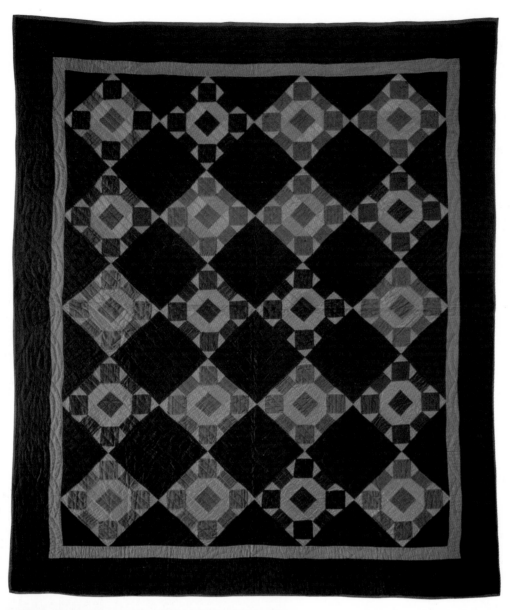

96. Rolling Stone, 1925. 84″ x 69″. Each of the four inside corners of this piece is dated and initialed in the quilting "January 28, 1925—L.M."

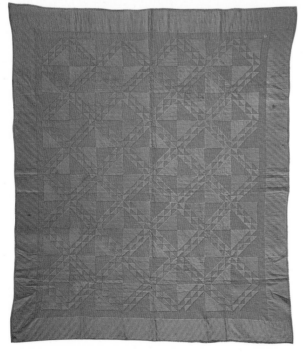

97. Lady of the Lake, 1915–1925. 86″ x 72″. This pattern is seldom seen in midwestern Amish quilts.

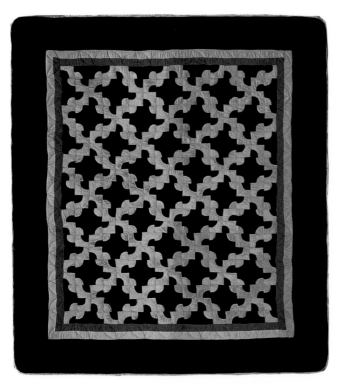

98. Rocky Road to Kansas, Honeyville, c. 1920. 76″ x 67″. Made by Lydia (Mrs. Joseph) Bontrager and purchased from her son Milo J. Bontrager.

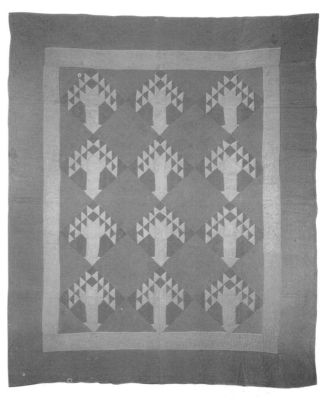

99. Tree of Life, Topeka, 1911. 82″ x 68″. Dated in each of the four corners "March the 1 year 1911."

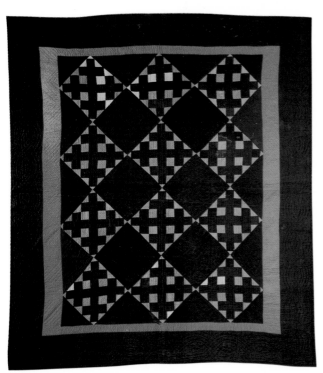

100. Double T, Topeka, 1922. 84″ x 73″. This quilt was made by Anna (Mrs. Urias V.) Yoder as a gift for her only daughter, Elizabeth, on the occasion of her marriage to Daniel J. Miller. Each of the four corners of the quilt is inscribed in the quilting with the date "March 9, 1922," and the initials "E.U.M." and "D.J.M."

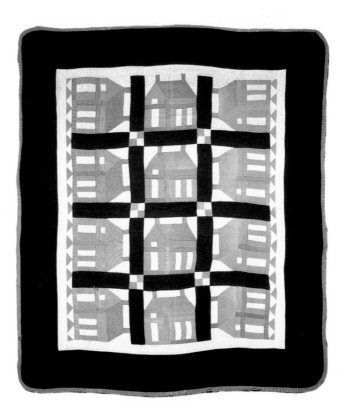

101. Schoolhouse, Ohio or Indiana, c. 1910. 72″ x 62″. The Schoolhouse design is seldom used by Amish quilters in the Midwest.

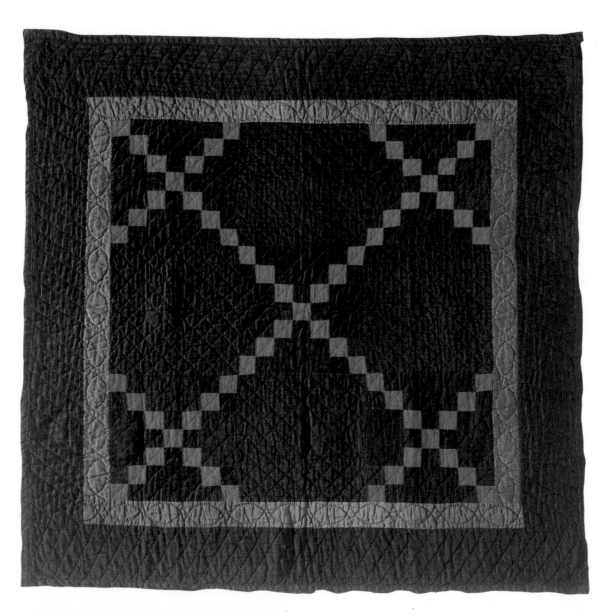

102. Crib quilt, Single Irish Chain, c. 1910. 40½″ x 40½″.
A rare example of the Irish Chain design in a mid-western Amish crib quilt.

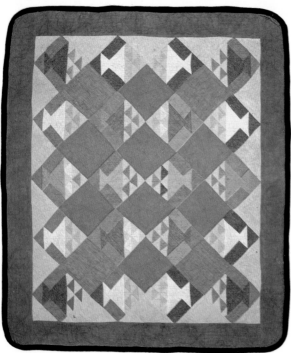

103. Crib quilt, Flower Baskets, Shipshe-
wana, c. 1925. 39″ x 33″.

104. Crib quilt, unnamed design, c. 1880. 38½″ x 32″. One of the earliest surviving examples of Amish quilts, this was made for Manessas Yoder, when he was living next to the Honeyville store.

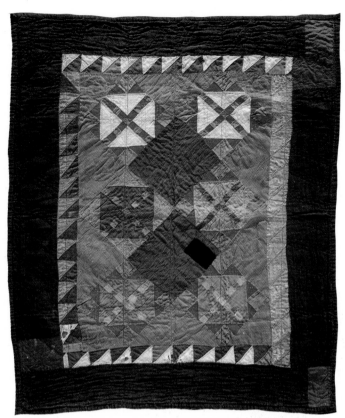

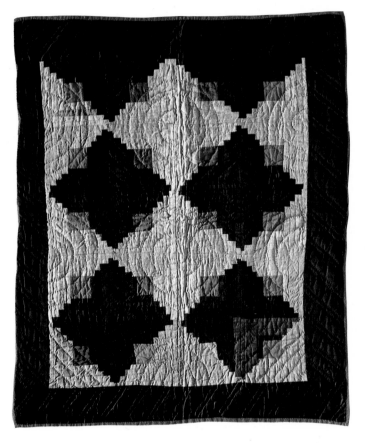

105. Crib quilt, Log Cabin, Light and Dark design, 1910–1920. 38½″ x 31″. It is most unusual to find a midwestern Amish Log Cabin quilt.

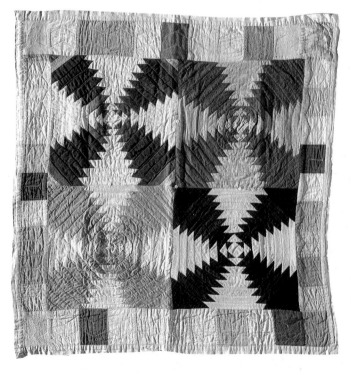

106. Crib quilt, Log Cabin, Windmill Blades design, 1920–1930. 34″ x 33″.

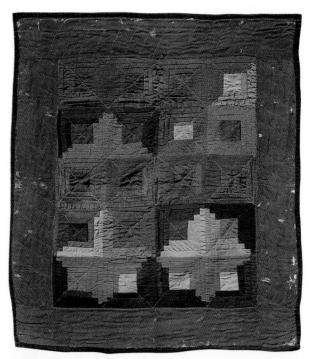

107. Crib quilt, Log Cabin, Light and Dark design, Shipshewana, c. 1900. 39″ x 33″. Made by Katie (Mrs. David J. L.) Miller for her daughter Susan and purchased in 1982 from Susan (Mrs. Daniel C.) Beachy of Honeyville.

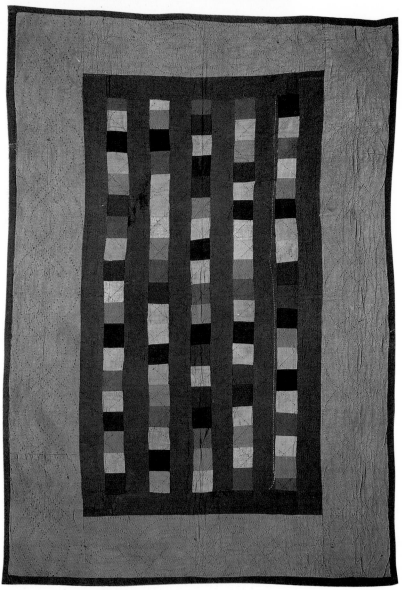

108. Crib quilt, Chinese Coins, 1910–1920. 48″ x 32″. This pattern is rarely seen in Amish crib quilts.

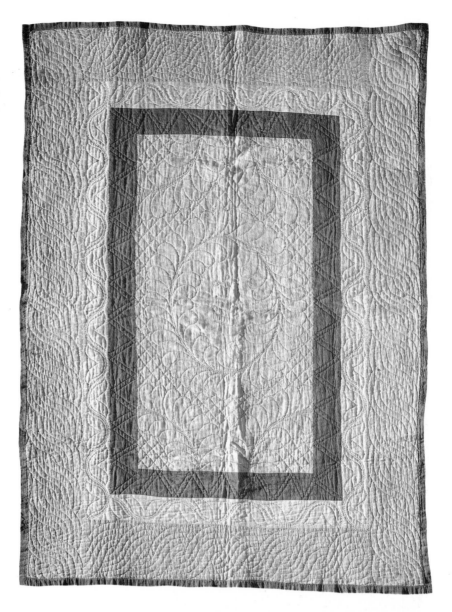

109. Crib quilt, Inside Border, Emma, 1913. 48″ x 35″. Although this is usually an Ohio design, this piece was made in Indiana, and it is dated in the center oval.

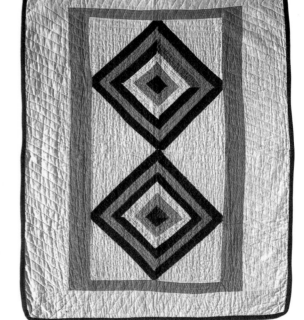

110. Crib quilt, Double Diamond, 1900–1920. 40″ x 33″. This is a rarely seen pattern, particularly in an Amish quilt.

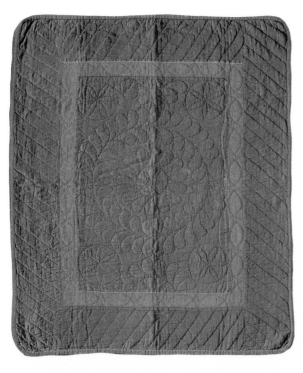

111. Crib quilt, Inside Border, probably Ohio, c. 1915. 36½″ x 30″.

112. Crib quilt, Inside Border, Indiana or Ohio, 1915–1925. 40½″ x 35½″.

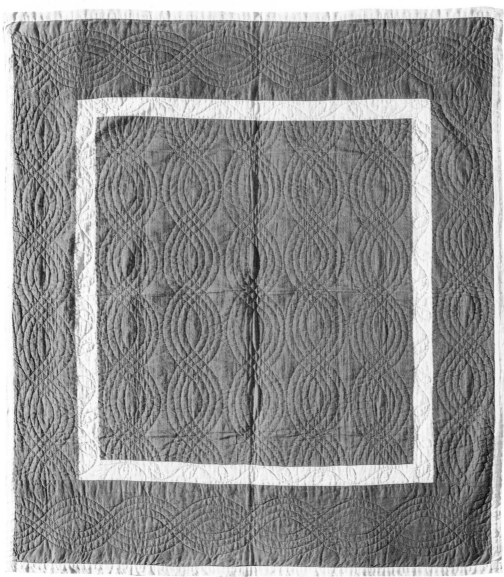

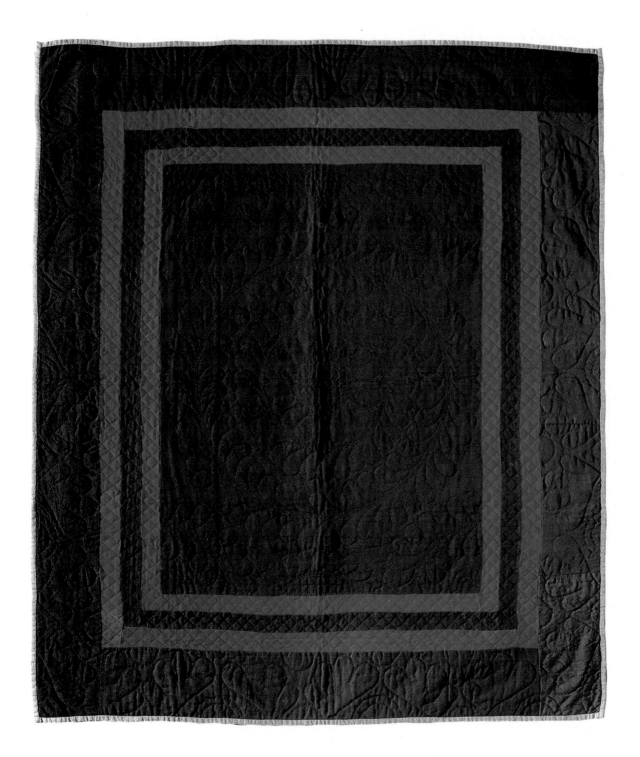

113. Crib quilt, Double Inside Border, Ohio, 1915–1930. 45″ x 37½″.

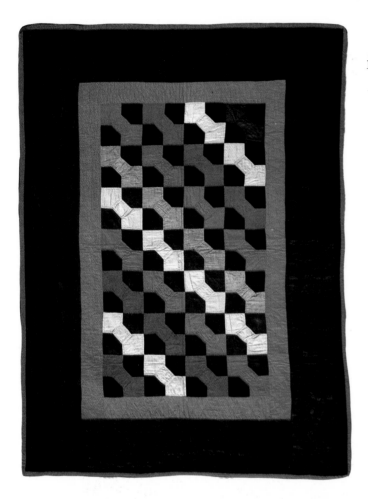

114. Crib quilt, Bow Tie, c. 1920. 62″ x 44″.

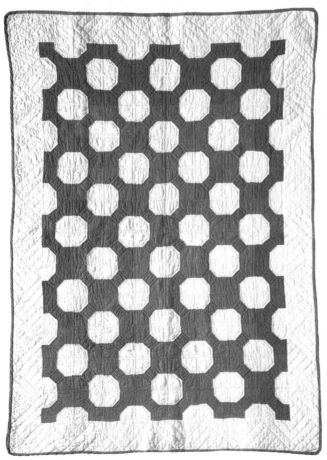

115. Crib quilt, Bow Tie variation, Topeka, 1930. 56½″ x 39½″. Made by Susan Schrock. Blue-and-white quilts were popular with the Indiana Amish in the years 1910–1940. This was not the case with other Amish communities.

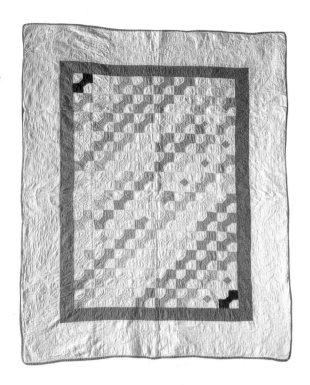

116. Crib quilt, Bow Tie, Honeyville, 1940. 56″ x 45″. This is one from the only pair of Amish crib quilts I have discovered so far.

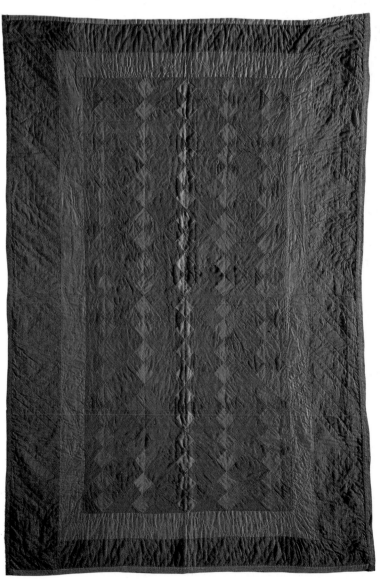

117. Crib quilt, Four Patch Chain, 1920–1930. 58″ x 37″.

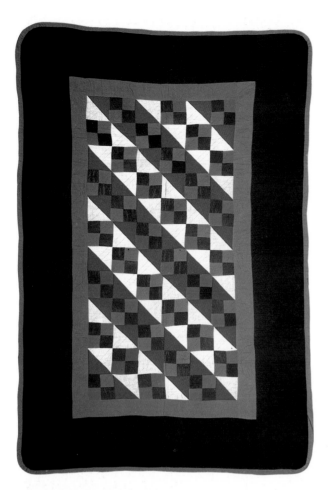

118. Crib quilt, Four Patch Straight Furrow, Indiana or Ohio, 1915–1930. 49½″ x 33″.

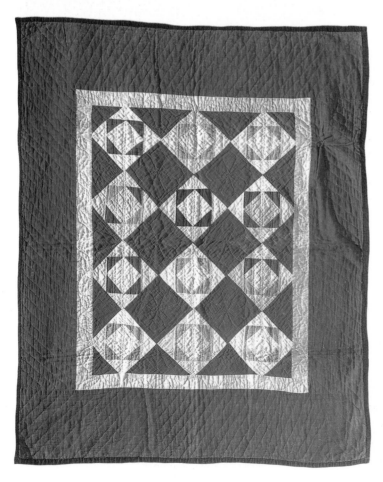

119. Crib quilt, Diamond in the Square variation, 1910–1920. 46½″ x 37″.

120. Crib quilt, Nine Patch, 1900–1915. 34″ x 29″.

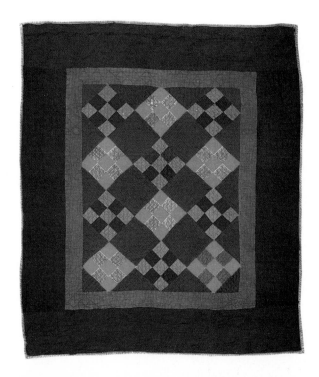

121. Crib quilt, Nine Patch, Indiana or Ohio, 1910–1925. 50½″ x 42½″.

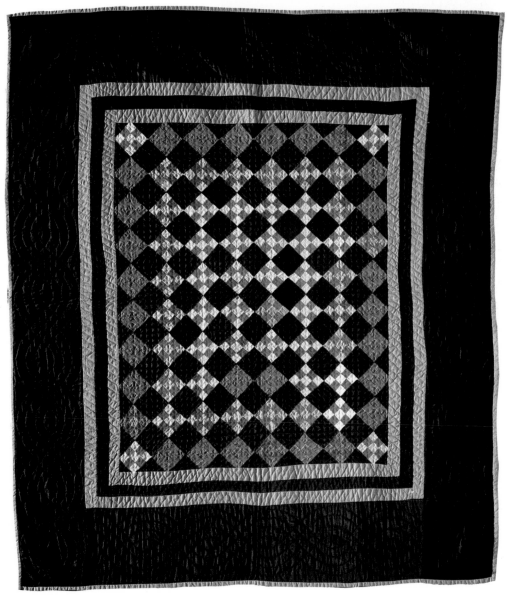

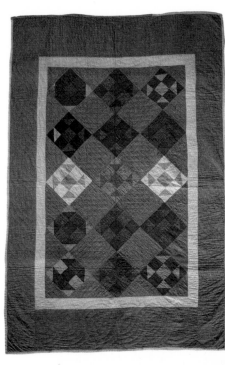

122. Crib quilt, Shoofly, 1900. 68″ x 44″. The date "March 21, 1900," is quilted in the border.

123. Crib quilt, Rabbit's Paw variation, Topeka, 1930. 43″ x 36″. Made by Mrs. Nathaniel Miller for her first son, Amos.

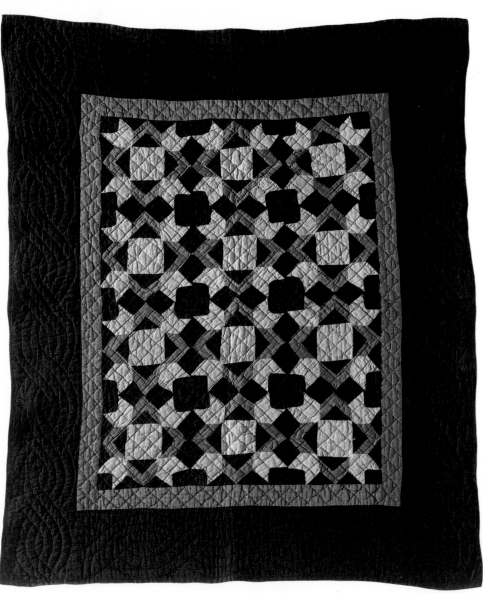

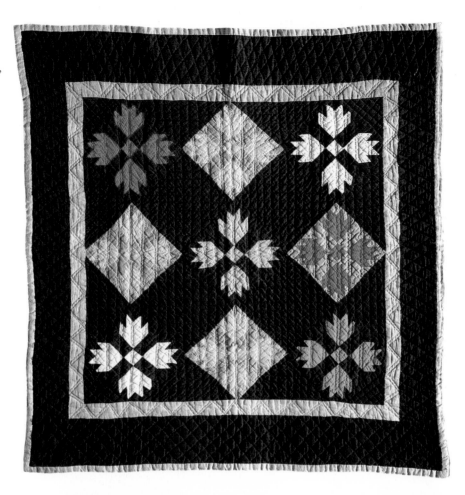

124. Crib quilt, Bear's Paw,
1900–1920. 33½″ x 32″.

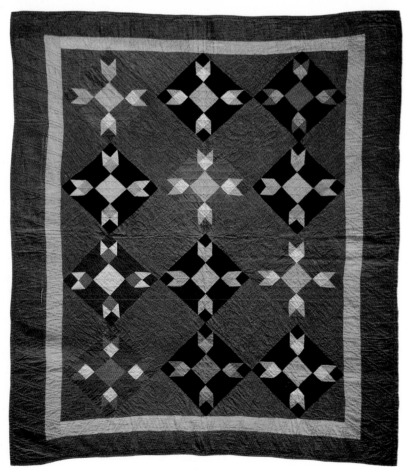

125. Crib quilt, Rabbit's Paw, Middlebury,
1915. 55½″ x 48″. Made by Mrs. Amanda
Yoder.

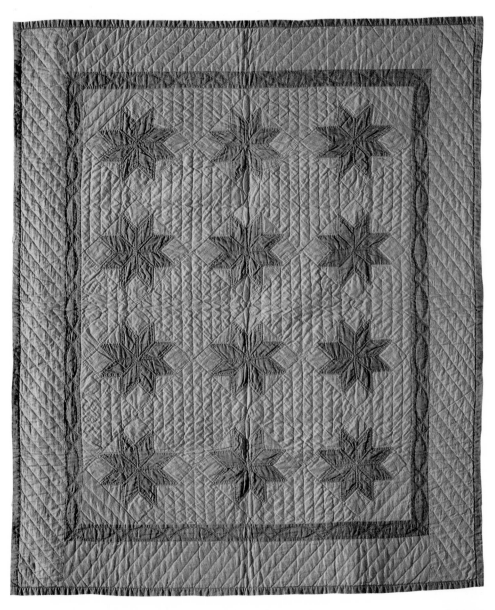

126. Crib quilt, Le Moyne Star, Indiana or Ohio, 1885. 44″ x 36″.
The quilt is initialed "S.C." and dated "1885," thus making it one
of the earliest documented crib quilts in the collection.

127. Crib quilt, Columbia Star, c. 1920. 51″ x
37″. This is an interesting variation of the
Tumbling Blocks pattern.

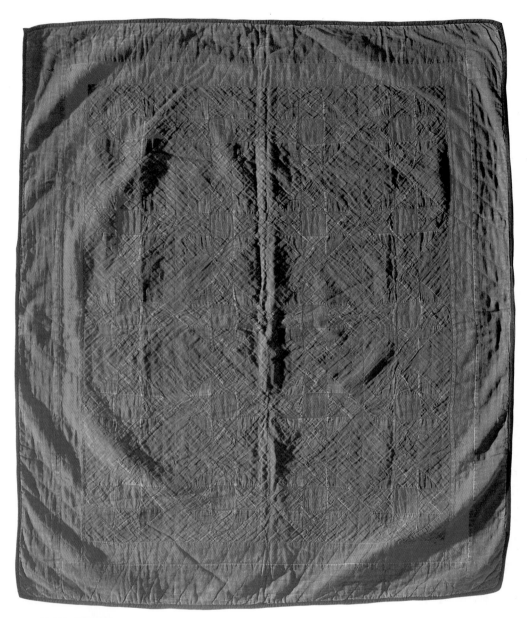

128. Crib quilt, Ohio Star, 1910–1930. 43″ x 36″.

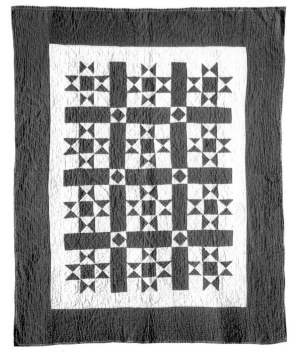

129. Crib quilt, Ohio Star, Yoder Corner (near Honeyville), 1913. 48″ x 38″. Made by Polly Bontrager.

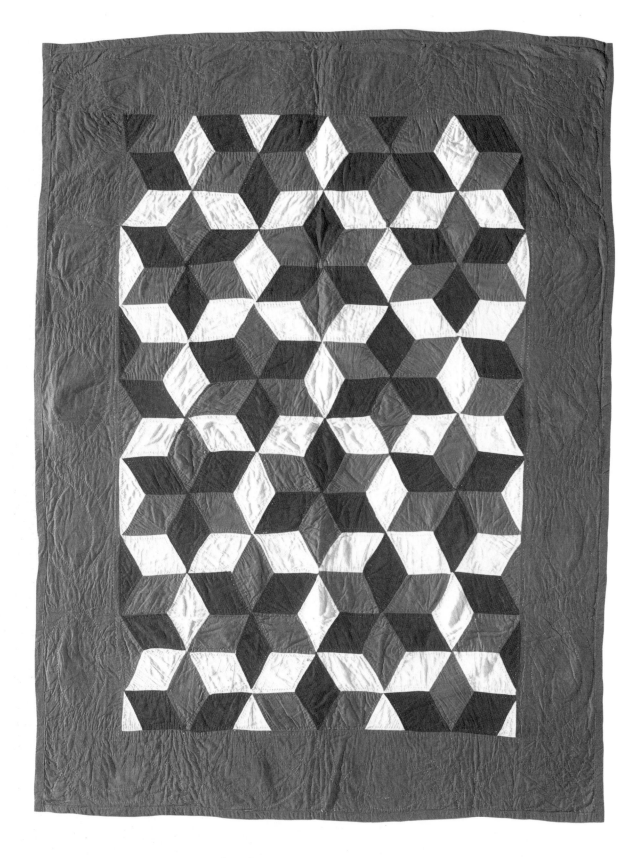

130. Crib quilt, Le Moyne Star, 1920–1940. 51½″ x 38″.

131. Crib quilt, Tumbling Blocks, 1915–1925. 51″ x 39½″.

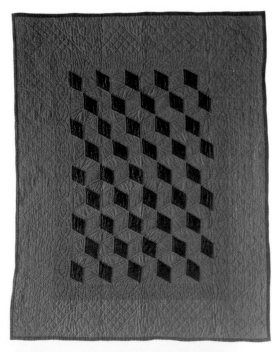

132. Crib quilt, Garden Maze with Nine Patch Cross, Topeka, 1900. 46″ x 41″. Made by Mrs. Urias V. Yoder.

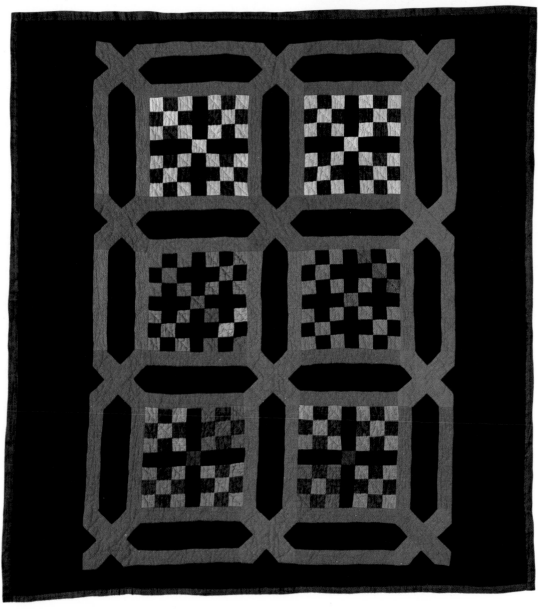

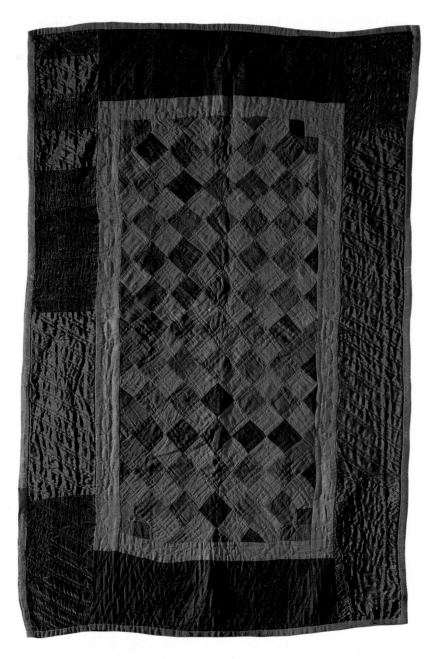

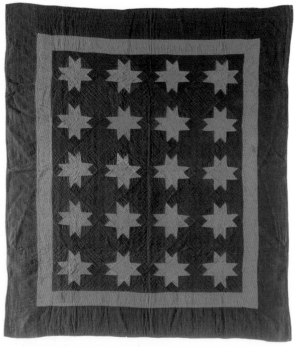

133. Crib quilt, One Patch, 1900–1915.
58″ x 36″.

134. Crib quilt, Variable Star, Topeka, 1925.
48″ x 40½″. Made by Mrs. Henry Miller.

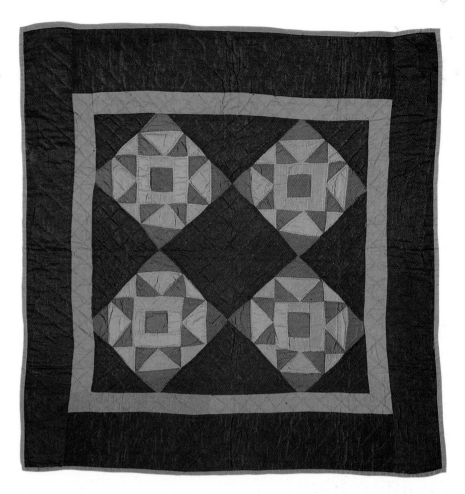

135. Crib quilt, unnamed design, 1930–1940. 38″ x 35½″.

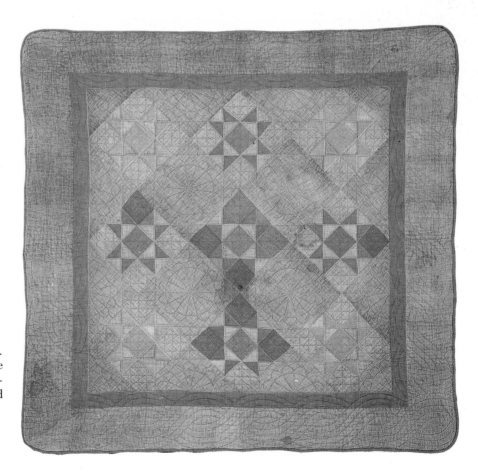

136. Crib quilt, Ohio Star, c. 1915. 43″ x 42″. This crib quilt was made for Bertha Bontrager, and it was purchased from her parents, Mrs. and Mrs. Henry Yoder.

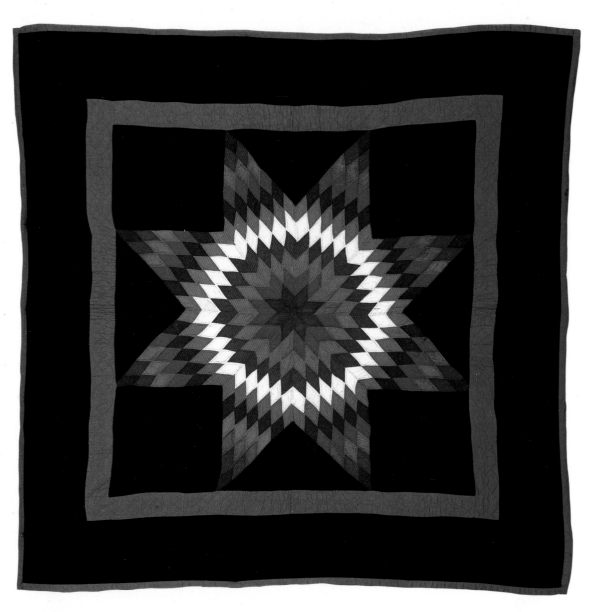

137. Crib quilt, Lone Star, Ohio or Indiana, 1910–1920. 53″ x 53″.

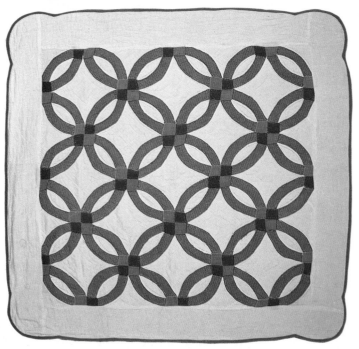

138. Crib quilt, Double Wedding Ring, Ship-shewana, 1948. 39″ x 38″. This piece was made by Mrs. Rudy Bontrager and was purchased at the estate sale of Levi L. Yoder, to whom it had been given for his first child.